IMAGES
of America

WEST POINT AND CLAY COUNTY

IMAGES
of America

WEST POINT AND
CLAY COUNTY

Jack D. Elliott Jr., Elizabeth A. Calvert,
and Rebecca M. Riley

ARCADIA
PUBLISHING

Published by Arcadia Publishing
Charleston, South Carolina

Printed in the United States of America

Library of Congress Control Number: 2014957227

For all general information, please contact Arcadia Publishing:
Telephone 843-853-2070
Fax 843-853-0044
E-mail sales@arcadiapublishing.com
For customer service and orders:
Toll-Free 1-888-313-2665

Visit us on the Internet at www.arcadiapublishing.com

*And now, looking back and down, you see all Yoknapatawpha
in the dying last of the day beneath you.
And you stand suzerain and solitary above the whole sum of your
life . . . First is Jefferson, the center, radiating weakly its puny
glow into space; beyond it, enclosing it, spreads the County, tied
by the diverging roads to that center as is the rim to the hub by
its spokes, yourself detached as God Himself for this moment
above the cradle of your nativity and of the men and women
who made you, the record and chronicle of your native land
proffered for your perusal in ring by concentric ring like the ripples
on living water above the dreamless slumber of your past.*

—William Faulkner, *The Town*

CONTENTS

ACKNOWLEDGMENTS

We should offer a clarification. This book is not an objective overview of the history of West Point and Clay County. It is, first and foremost, a collection of historic photographs primarily depicting landscapes and buildings, images that are designed to capture in a small way a long-gone way of life. Focusing on photographs prevents an objective account, because the county's history is not consistently represented visually. The first photograph in the United States was made about 1839, several years after the West Point area began to be settled. Although photography flourished during the Civil War, when Matthew Brady's photographers covered the event, there are no photographs from that time for the Clay County area, other than a few portraits. Decades later, photographs became sufficiently common as to be well represented in the collections available to us. We know, for example, of no photographs that depict antebellum West Point, Palo Alto, Colbert, or Barton. Furthermore, we find far more photographs of urban West Point than of the rural county. Also, there are far more photographs of white homes than black homes, and very few of structures such as barns, smokehouses, corn cribs, warehouses, and privies. The earliest known photographs are mostly portraits, which are largely outside the scope of this book, although we do include the c. 1861 photograph of "the Chandler boys," which has gained recent notoriety on PBS's *History Detectives*, and a nonphotographic portrait of Moses Jordan, the founder of West Point. It was around the turn of the last century that the number of photographs increased greatly. Consequently, many of the photographs in this book date to the first two decades of the 20th century. Other than those, we use several images of more recent vintage that depict early buildings, for which there are no contemporary photographs.

To the staff of the Bryan Public Library, who put up with us, and to all the individuals and organizations who were generous with their time and photographs, we extend our gratitude. We would especially like to thank Marcia Phyfer for editing the manuscript. Unless otherwise noted, all images appear courtesy of the Bryan Public Library.

INTRODUCTION
LANDSCAPES OF MEMORY

Much of the information about the past comes in the form of images, a collage of pictures winnowed from what has happened. Images of the landscape are perhaps the most distinctive, evoking complex scenes of human life, with buildings, yards, fences, and transportation facilities. This book presents for the reader a mosaic of such images of West Point and Clay County, Mississippi.

Clay County and its county seat, the town of West Point, are located in northeast Mississippi. With its eastern boundary on the Tombigbee River, the county stretches westward across the fertile Black Prairie and beyond, terminating in the Flatwoods to the west. It includes the Kilgore Hills, which form the southern tip of the Pontotoc Ridge. The county is divided by Tibbee Creek and its tributary, Line Creek, which form the historical boundary line that once separated the territory of the Chickasaw tribe of Indians to the north and the Choctaw tribe to the south. The Chickasaws and Choctaws were the most recent names of the Indian societies that had inhabited the area since the end of the Ice Age, about 12,000 years ago.

The Clay County area was ceded to the United States in the 1830 Treaty of Dancing Rabbit Creek with the Choctaws and the 1832 Treaty of Pontotoc with the Chickasaws. These areas, Choctaw and Chickasaw, were then surveyed and sold by the federal government. Consequently, Clay County is divided into two survey areas, with the townships and sections of each being part of two separate survey grids.

Settlers moved in to establish farms, and the area was soon organized into counties (none of which at the time were Clay County) to provide the basics of local government; it would be 40 years before Clay was established. The eastern part of the area that would become Clay County initially made up the northwestern corner of Lowndes County, along with a two-mile-wide strip of Monroe County. The western part comprised the southeastern corner of Chickasaw County in the north and the northern part of Oktibbeha County in the south.

The economic motivation for settling the area, like that for most of the Deep South, was the production of cotton. Increased demand for the fiber arose from the Industrial Revolution, in part due to the development of textile mills in England and New England, which increased the production of cloth. This, in turn, meant an increase in demand for cotton. Another factor was Eli Whitney's 1793 invention of the saw gin, which separated fiber from the seed, thereby making cotton production more economical. Both of these factors contributed to the increasing demand for cotton, making its production more lucrative and leading to a boom in production. These economic conditions drove the settlement of the Deep South, which was climatically well-suited for growing the crop.

Prospective farmers purchased land and built rudimentary housing of logs for their families and their slaves (if they owned any) to provide shelter until the farms could be established. Meanwhile, land had to be cleared and cultivated. Agricultural production had two modes: commercial and subsistence. The commercial component was usually cotton, which served as the cash crop. The subsistence component was designed to feed the people and animals on the farm, thereby eliminating the need to purchase most foods. Subsistence production primarily consisted of corn, sweet potatoes, garden vegetables, hogs, and cattle.

The earliest houses were usually of the single-pen (one room) type, or the somewhat larger dogtrot type, consisting of two rooms separated by an open hallway. Dogtrots were early termed "double cabins," a name that has largely been forgotten today, although it has been preserved in the name of "Double Cabin Creek," located in the western part of the county, near Pheba. Although the popular image of cotton planters has them living in large, two-story mansions with columns across the front, in most parts of the Clay County area and many other parts of the Black Prairie, the homes of rural planters were not much bigger or better than the homes of their slaves. As always, there were a few exceptions, most notably the George H. Young home, Waverly, located at Waverly on the Tombigbee River.

While subsistence produce was consumed at home and required little in the way of transportation, cotton, on the other hand, had to be marketed. That meant shipping it to the Northeast and across the Atlantic Ocean. Initially, the only economical transportation means for shipping cotton and for importing manufactured goods was via waterways. For the Clay County area, the Tombigbee River and its tributaries, such as Tibbee, Line, and Sookatonchee Creeks, were all considered navigable. The Tombigbee ultimately linked to the port of Mobile. Steamboats hauling cotton plied the Tombigbee River downstream to Mobile, then headed back upstream, loaded with commodities and merchandise. Keelboats and flatboats were used on the smaller streams as well as on the Tombigbee.

Small towns and villages began to develop to serve the needs of the local population by providing stores, post offices, doctors, and social life. The earliest of these villages were along the Tombigbee River at Colbert, Barton, and Waverly, while those farther inland—Palo Alto, Cedar Bluff, Montpelier, and West Point—came somewhat later. The town of West Point had its origins in 1846 as a post office and a store at the intersection of the Columbus to Houston Road and the Old White Road that connected Aberdeen on the Tombigbee River to French Camp on the Natchez Trace. West Point gained its name by virtue of the fact that, at the time, it was the "western point" in what was then Lowndes County, Mississippi, with the Lowndes-Oktibbeha county line only a few hundred yards to the west.

The area was transformed by the coming of the railroad. In 1848, the Mobile & Ohio Railroad was chartered to build a rail line connecting Mobile on the Gulf Coast with Columbus, Kentucky, which was located on the Mississippi River, just downstream from the mouth of the Ohio River. The railroad, built northward on the west side of the Tombigbee River, provided an alternate route for passenger and freight traffic bound for Mobile. New towns were established along its route, while older ones were revitalized. By 1855, the survey extended as far north as a point one mile east of the West Point Post Office, and a depot site was selected there. Moses Jordan, a local planter, donated land to the railroad for a depot and had a town plat surveyed around the depot grounds to establish the town, which was to be called West Point. Consequently, the post office was moved to the new site. When the railroad was completed to West Point in December 1857, the town boomed, and it was incorporated the following year. By the time the 1860 census was taken, the population had reached approximately 500.

One consequence of the arrival of the railroad to West Point was the appearance of additional sawmills, which ultimately resulted in a shift from log construction to frame construction. The railroad made it easier to import steam engines, and steam engines promoted saw milling and the use of milled lumber. After the Civil War, the construction of log buildings became increasingly rare.

West Point's growth was curtailed by the outbreak of the Civil War, which eventually resulted in a breakdown of commerce. Unlike many parts of the South, the area around West Point saw relatively little Union activity and little physical damage. On April 20–21, 1863, a Union cavalry force under Col. Benjamin Grierson passed through the western part of what would become Clay County on the way to Baton Rouge, an event known as "Grierson's Raid." In conjunction with the raid, a brief skirmish took place near Palo Alto. In February 1864, a Union cavalry force of about 7,000 under Gen. William Sooy Smith, moving from Memphis to Meridian to link up with Gen. William T. Sherman, briefly occupied West Point before retreating to Memphis. During their

stay, destruction to the town was minimal and focused primarily on the Mobile & Ohio depot. During the Union occupation, a brief engagement, now known as the Battle of Ellis Bridge, or the Battle of West Point, occurred west of town on Sookatonchee Creek.

After the war, the area was economically devastated. Furthermore, the slaves, having been freed, became a political force. However, with their new status, they were dislocated within an agricultural economy that was the main source of jobs. Many of the former slaves became sharecroppers. Instead of living in a cluster of houses called a "quarter" located near the land owner's house, they began to live in dispersed housing, each near a parcel of land that the tenant was allowed to farm as an independent producer. He paid for his use of the land either through rent or through a certain percentage or "share" of the cotton sales.

During the postbellum period, many new counties were created in Mississippi by chopping portions out of previously established counties and reassembling them into new ones. Clay County was created in 1872 by an act of the state legislature out of portions of Chickasaw, Lowndes, Monroe, and Oktibbeha Counties, with West Point as the county seat. West Point itself probably played a role in terms of encouraging this legislation, because transforming the town into a county seat was beneficial to its prospects for growth. Clay County was originally named Colfax County, after the Republican vice president, Schuyler Colfax. After the end of Reconstruction in 1876 and the return of Democrats to power in Mississippi, the name was changed to Clay County in honor of Henry Clay of Kentucky (1777–1852), who was nicknamed "the Great Compromiser" for his role in the US Senate. With the establishment of Clay County, the two focal points of this book had come into being.

The 1880s saw a railroad boom for West Point and Clay County. The construction of two new railroads effectively turned the town into a prominent crossroads. The first was the Canton, Aberdeen & Nashville Railroad (later the Illinois Central), which ran from near Canton to Aberdeen through West Point, which it reached about 1884. The second, originally known as the Georgia Pacific, later the Southern, and even later the Columbus & Greenville, was constructed through West Point in 1889 and spawned the birth of several rural depots, including Waverly, Stephen's Switch, and Mhoon Valley, and the two towns of Cedar Bluff and Pheba.

By the early 20th century, West Point had begun to develop industries associated with cotton in the form of a textile mill, a pajama factory, and a cottonseed mill. The spread of the automobile and the development of paved roads, most notably state-maintained highways, revolutionized social and economic patterns. Rural hamlets declined as larger centers of commerce and industry, such as West Point, became more accessible. Rural dwellers, able to commute into town to work, got jobs in the service and manufacturing sectors.

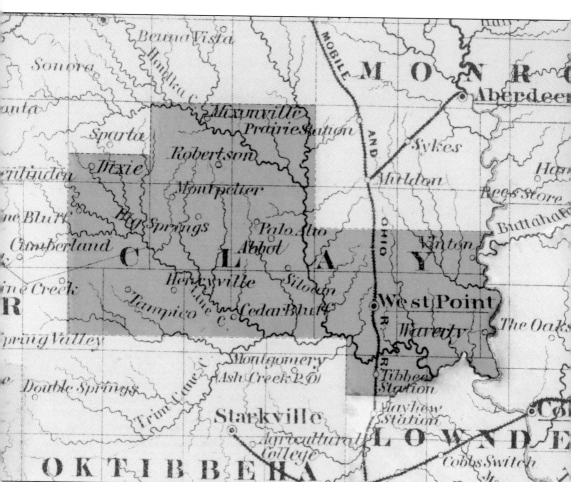

MAP OF CLAY COUNTY, 1882. This map was drafted 10 years after the county was established in 1872. Depicted on it is the Mobile & Ohio Railroad, which ran north and south through West Point and Tibbee Station and was constructed in the late 1850s. Clay County's other two railroads were the Canton, Aberdeen & Nashville and the Georgia Pacific, constructed a few years later. Both ran through West Point. Also to be seen are communities of antebellum origin such as Waverly, Vinton, Palo Alto, Siloam, Cedar Bluff, Tampico, Montpelier, and Tibbee Station. Additionally, several postbellum communities are depicted, including Abbott, Robertson, Big Springs, Henryville, Dixie, and the very short-lived Mixonville. The map originally appeared in *The National Atlas of the United States and the Dominion of Canada*, published in 1882 by O.W. Gray & Son of Philadelphia. (Courtesy of Elizabeth Calvert.)

One

THE MOUND

Just south of West Point, a lone Indian mound—the Brogan Mound—stands on the east side of Highway 45 Alternate. Almost hidden by the trees that cover it, few would notice the mound were it not for the historical marker placed beside it. There are few images of the prehistoric past to be found on the landscape of Clay County. The Brogan Mound is certainly one of the most visible and well-known of those images.

Sometime before 12,000 B.C.—possibly thousands of years before—the ancestors of the first inhabitants began trickling into the New World from the Old World. For millennia, they lived as foragers until the first attempts at agriculture began with the domestication of corn, squash, and beans in Mexico, a development that eventually spread throughout North America, allowing people to produce their own food and thereby allowing them to form, in some cases, large fortified towns, such as the site known today as Moundville, Alabama.

The construction of mounds has a long history, beginning, as it appears now, as early as 6,000 years ago. When Europeans began arriving in North America, they found numerous earthen mounds on the eastern part of the continent. Yet there were almost no Indian groups who built mounds at the time, leading to the advancement of the now-discredited hypothesis that mounds were constructed by a vanished civilization of people called the Mound Builders.

Mounds serve as a tangible reminder of the ancient past, and are far, far older than any other structures. Because of their evocative quality, they have served as the focal point of stories, often involving imaginary events and buried treasure. For over a century, the Brogan Mound was believed to be one of two burial mounds built to inter the dead following a battle between the Chickasaw and Choctaw tribes, probably in the 18th century. In 1934, state archaeologist Moreau Chambers excavated the mound and found that it was far older than the legend had claimed it to be. In reality, it was almost 2,000 years old, dating approximately to the time of Christ, and therefore far more ancient than previously suspected.

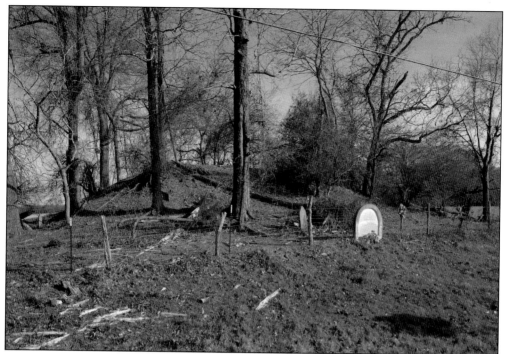

BROGAN MOUND, 2015. Estimated to be approximately 2,000 years old, the mound stands to the east of Highway 45 Alternate, just south of the city of West Point. This photograph was taken in the wintertime, when the trees have lost their leaves. During the summer, the mound is almost invisible, covered by a canopy of dense foliage. (Photograph by Jack Elliott.)

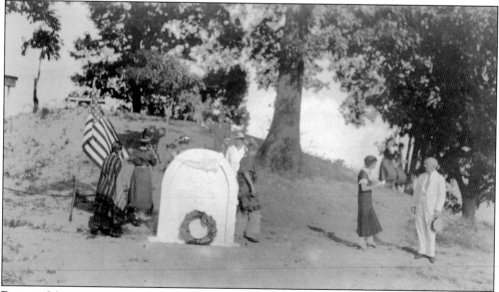

BROGAN MOUND, 1930s. Members of the Horseshoe Robertson Chapter of the Daughters of the American Revolution (DAR) conduct a commemorative ritual at the mound. Note the wreath at the base of the monument and the American flag. The monument, erected by the DAR in 1934, incorrectly identified the site as a Chickasaw burial mound. With few surrounding trees at the time, the mound can be clearly seen.

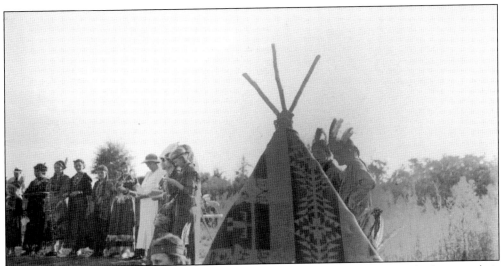

DAR Commemoration at Brogan Mound, 1930s. Note the boys wearing feathers on their heads and the improvised teepee. Teepees were used by the Indians of the Great Plains, but not by the Chickasaws and Choctaws of Mississippi. Concepts of Indian culture were often based on Western films.

Brogan Mound, 1950s. Covered with secondary growth, the mound can be seen directly behind the concrete marker erected by the Daughters of the American Revolution. Members of the DAR shown here are, from left to right, West Point historian Ruth White Williams, Carolyn (Mrs. Hugh) Cooper, and Mrs. Noel Malone.

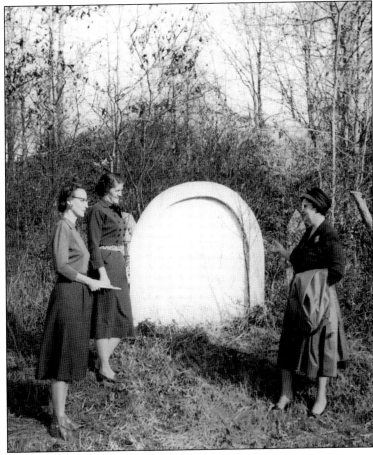

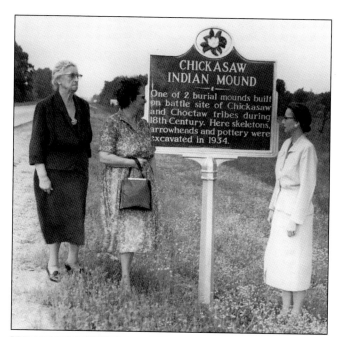

OLD HISTORICAL MARKER. The "Chickasaw Indian Mound" state historical marker was erected adjacent to the Brogan Mound around 1955. While the marker mentions that the mound had been excavated by the state in 1934, it omits the fact that the excavation demonstrated that the mound predated the Chickasaws by over 1,000 years. After being hit by an automobile, the marker was eventually replaced by a more accurate one.

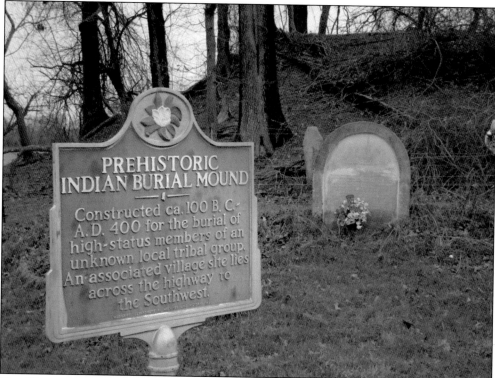

NEW HISTORICAL MARKER, 2015. After the first state marker was demolished by an automobile, another one was erected to take its place. This marker accurately reflects the results of the 1934 archaeological excavation. Referring to the mound as a "prehistoric Indian burial mound" dating to approximately 100–400 A.D., the marker notes that it was too early to be associated with any known tribal group. (Photograph by Jack Elliott.)

Two

THE RIVER

When Clay Countians refer to "the river," they mean only one: the Tombigbee River. It has its headwaters in northeast Mississippi and flows southward to form the county's eastern border, then passes into Alabama and eventually reaches Mobile Bay. It received the name "Tombigbee" in error. The name *Iatombikbee*, which means "coffin maker" in Choctaw, was originally the name of a creek in Alabama. In 1735, the French built a fort on the river near the creek's mouth, calling it Fort Tombecbee, a variant of the creek's name. By the 1770s, the fort, through its prominence, gave the name to the river. George S. Gaines, the US factor to the Choctaws, once asked the Choctaw chief Pushmataha what they called the river. Pushmataha replied, "Hatchie," which means simply "the river."

Before the era of railroads and, later, of highways, the Tombigbee River was the primary artery that connected Clay County to the outer world. In the early 19th century, it was used by steamboats, keelboats, and flatboats to ship cotton and other products to market and for the return flow of merchandise and passengers.

Some of the earliest settlements in what would become Clay County were on the banks of the river. Ferries were established at key crossing points, such as Barton and Waverly. River towns were established, including Colbert, which was founded in late 1835. Then, after it was flooded in December 1847, another town, Barton, was established on higher ground to the north. Barton Ferry derived its name from this town. Another major crossing was at Waverly, where a cluster of plantation homes developed, along with a ferry, post office, and warehouse facilities.

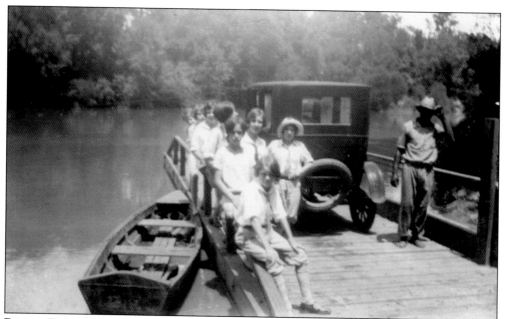

BARTON FERRY, 1920s. An automobile and its youthful passengers are about to cross the Tombigbee River at Barton Ferry with the help of ferryman "Bear." The ferry was located on the river at the site of the extinct town of Barton (1848–c. 1860). It was discontinued in 1962, the year that the Highway 50 bridge was opened across the river. (Courtesy of Ellen Sugg.)

CEDAR OAKS HOUSE. Cedar Oaks was the last surviving house from the extinct river town of Barton. Constructed around 1850, it was once the home of merchant James M. Collins, who, in the late 1850s, moved his home and business to the new railroad town of West Point. (Photograph from the 1978 Historic American Buildings Survey; courtesy of the Library of Congress.)

WAVERLY FERRY.
Opened when
Thomas B. Mullens
was licensed in
1834 to operate a
ferry at the crossing
previously known as
"Pitchlynn's Ford,"
this ferry flourished
for decades on the
road from Columbus
to Houston. Waverly
was first known as
Mullens' Bluff because
of Mullens' Ferry. The
ferry was discontinued
in 1962. (Courtesy
of Jack Elliott.)

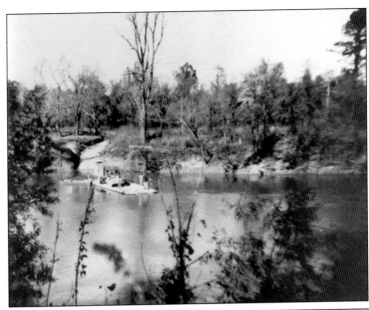

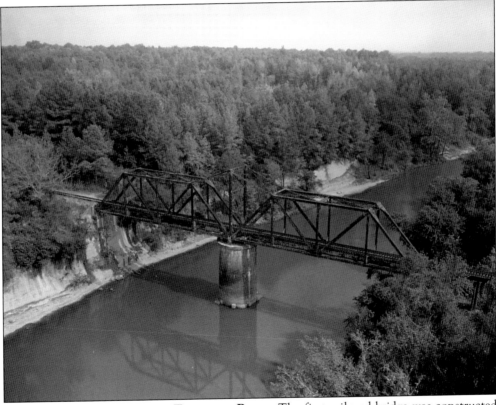

RAILROAD BRIDGE ACROSS THE TOMBIGBEE RIVER. The first railroad bridge was constructed about 1888 by the Georgia Pacific Railroad (later the Southern Railroad, then the Columbus & Greenville Railway). It was replaced with the present bridge in 1914. Waverly is on the left side of the river. (Photograph from the 1978 Historic American Buildings Survey; courtesy of the Library of Congress.)

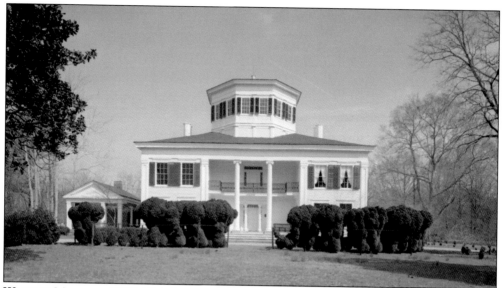

WAVERLY MANSION, 1975. This house is a monumental remnant of the plantation community that was also known as Waverly. Constructed in the 1850s, it served as the home and command center of the plantation empire of Col. George Hampton Young (1799–1880), a native of Georgia who founded the community in the late 1830s. (Photograph from the 1978 Historic American Buildings Survey; courtesy of the Library of Congress.)

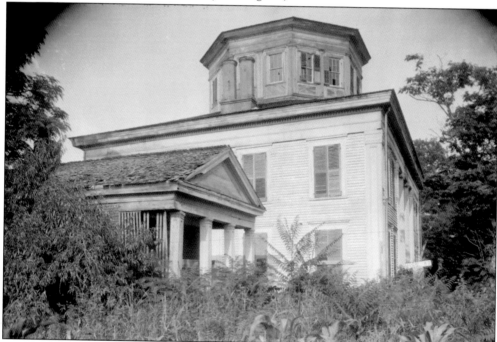

WAVERLY MANSION, 1936. This photograph was taken about two decades after the abandonment of the home following the death of George H. Young's son, Capt. Billy Young, in 1913. Note the office building in the foreground, which may have also been used as a commissary for distributing goods to local residents. (Photograph from the 1936 Historic American Buildings Survey; courtesy of the Library of Congress.)

FRONT PORCH, WAVERLY MANSION.
Although descendants of Colonel Young continued to own the house until 1962 and maintained it to some degree, it nevertheless deteriorated. In its state of abandonment and desolation, the mansion became a source of wonder for residents of the surrounding area, prompting many to visit. (Photograph from the 1936 Historic American Buildings Survey; courtesy of the Library of Congress.)

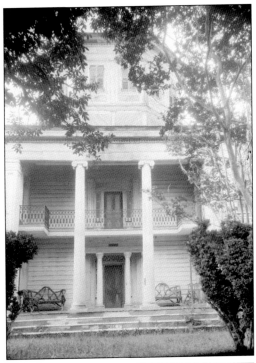

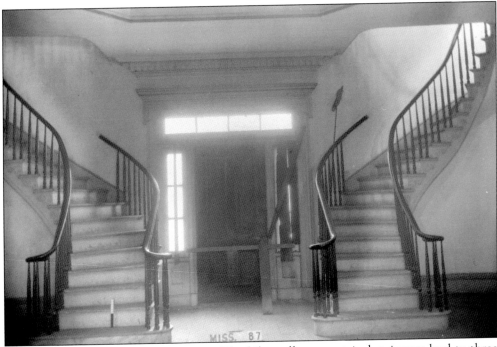

TWIN STAIRCASES, WAVERLY MANSION. The bilaterally symmetrical staircases lead to three successive levels of balconies in the rotunda. The light playing through the windows gave the abandoned building a ghostly, dreamlike atmosphere. The Robert A. Snow family began restoring the home in 1962. (Photograph from the 1936 Historic American Buildings Survey; courtesy of the Library of Congress.)

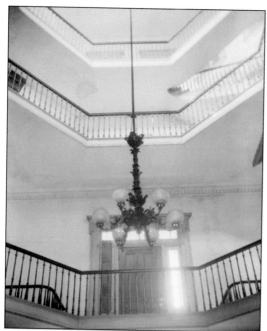

ROTUNDA, WAVERLY MANSION. Inside the rotunda, a visitor can look up for an awe-inspiring view of this most impressive architectural feature. Bedrooms open onto the second-floor balcony, seen in the lower part of the photograph. The third-floor balcony provides access to attic rooms, while the fourth-floor balcony, surrounded by windows, offers a magnificent view of the surrounding countryside. (Photograph from the 1936 Historic American Buildings Survey; courtesy of the Library of Congress.)

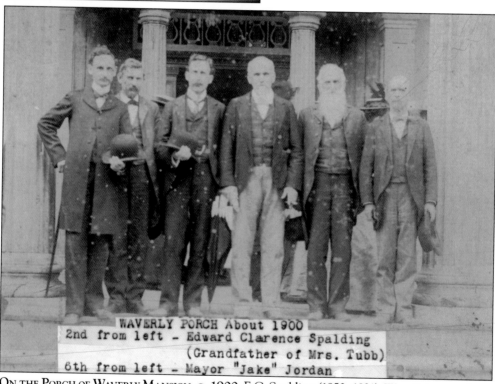

WAVERLY PORCH About 1900
2nd from left - Edward Clarence Spalding
(Grandfather of Mrs. Tubb)
6th from left - Mayor "Jake" Jordan

ON THE PORCH OF WAVERLY MANSION, C. 1900. E.C. Spalding (1850–1931), West Point merchant and former Clay County sheriff (1884–1888), is standing second from left. At far right is Charles L. "Jake" Jordan (1847–1906), mayor of West Point (1892–1902) and son of West Point's founder, Moses Jordan. The men standing third from right and second from right are probably the masters of Waverly, Capt. Billy and Maj. Val Young, respectively.

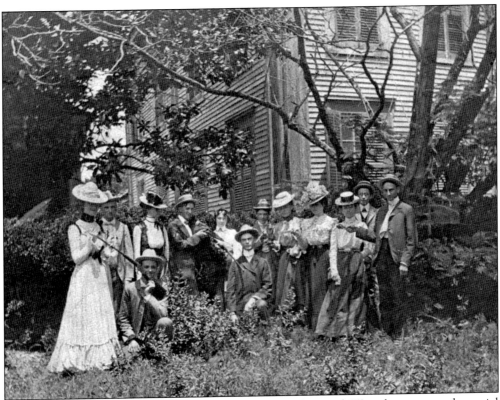

PICNIC AT WAVERLY, C. 1900. The mansion is in the background. Waverly was a popular social center in West Point and eastern Clay County in the late 19th and early 20th centuries. When it was abandoned following the death of the last Young family member, Capt. Billy Young, in 1913, visitors from Columbus and West Point continued to gather at Waverly on weekends.

BRICK GIN HOUSE AT WAVERLY. Used in the early 20th century, the gin house stood across the road from Waverly Mansion until it was demolished in the 1960s. The gin itself would have been on the second story. In the 19th century, an earlier gin house stood on the riverbank adjacent to the ferry. (Courtesy of Robert Snow.)

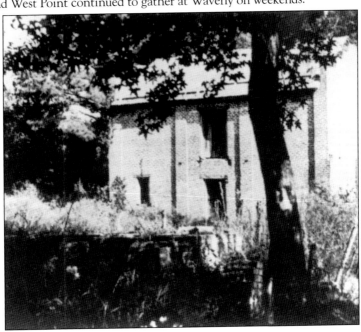

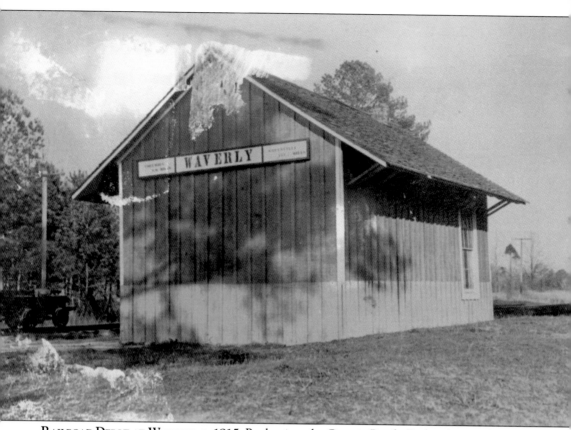

RAILROAD DEPOT AT WAVERLY, C. 1915. By the time the Georgia Pacific Railroad opened through Waverly about 1889, river transportation had long been on the decline. The small depot offered a ride by train into West Point or Columbus to those who would otherwise have to walk or travel by a horse and wagon.

Three

COTTON

The global economy is talked about today as though it is something new. In reality, trade on a worldwide scale began in the 1400s and 1500s with the explorations that led to the discovery of new worlds, such as Christopher Columbus's travels to the Americas and the concomitant expansion of geographical knowledge. The goal of exploration was the establishment of trade routes and the founding of trading posts and colonies for the acquisition and production of local goods that could be marketed globally. Various areas of the world subsequently developed economic specializations suited to their environments. For example, the colony of Virginia developed an economic base in tobacco production in the 1600s, growing commercially a crop that was indigenous to that area while marketing it to Europe, where there was a growing demand for it.

In the mid-1700s, the Industrial Revolution began in England, based, to a large degree, on new technology used in producing thread and textiles more efficiently, quickly, and, therefore, more cheaply, making these important products more readily available. Increased production meant an increased demand for the fibers used in the process, with cotton being a key source.

The humid, subtropical climate of the Deep South was ideally suited for growing short staple cotton, and this crop developed into the specialty of the region. The key technologies involved in its production and distribution were the cotton gin and new transportation modes, primarily steamboats and railroads. Cotton gins were used for separating the cotton fiber from the seeds. These facilities, initially animal-powered, were later generated in increasingly larger structures by steam engines and, eventually, by electricity. Cotton gins were once found in West Point and in almost every small town and crossroad hamlet in the county. Today, following the decline of cotton production, there are no operating gins in the county.

In the late 19th and early 20th centuries, cotton became the basis of additional economic activity, with the development of mills for producing cottonseed oil and factories for producing textiles and clothing.

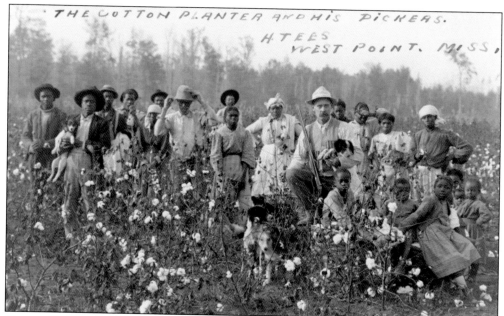

COTTON PLANTER AND PICKERS. Howard Tees photographed "The Cotton Planter and His Pickers" around 1908, probably near West Point. This image captures the field production of cotton that once dominated so much of rural Clay County. The white landowner is ready for bird hunting (note the dogs), and the black sharecroppers have gathered for a group photograph. (Courtesy of the Library of Congress, Prints and Photographs Division.)

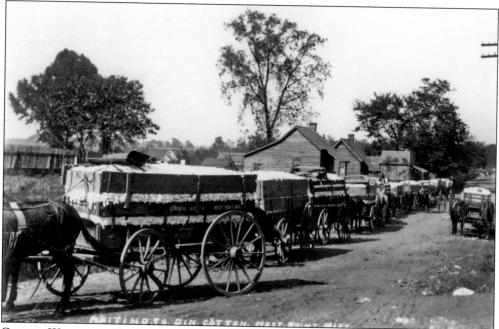

COTTON WAITING TO BE GINNED, 1907. Wagons of cotton await their turn at the gin, where the lint was separated from the seeds and formed into bales. This photograph by Howard Tees was probably taken on North Division Street, where two cotton gins were located. The houses alongside the road were probably the homes of African Americans. (Courtesy of Carolyn Atkins.)

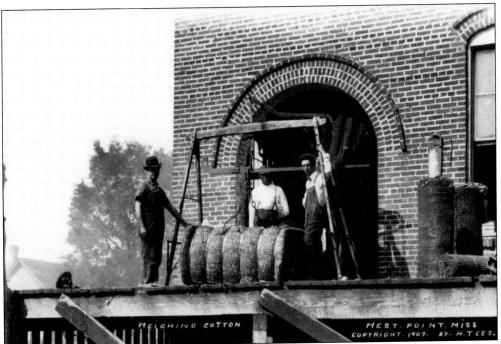

WEIGHING COTTON, 1907. At the exterior of a brick gin house on North Division, bales of cotton are weighed before being hauled off for storage and sale. The scale is the horizontal metal bar with a hook at one end. The weight of the bale was determined by adjusting a counterweight. (Photograph by Howard Tees; courtesy of Carolyn Atkins.)

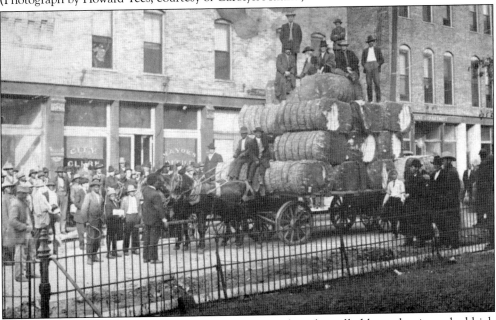

BALES OF COTTON ON JORDAN AVENUE. A wagon, ready to be pulled by mules, is stacked high with bales of cotton. Taken from the grounds of the courthouse, with its iron fence visible in the foreground, this photograph predates the construction of city hall in 1909. The city offices are visible in the background, on the north side of Jordan Avenue.

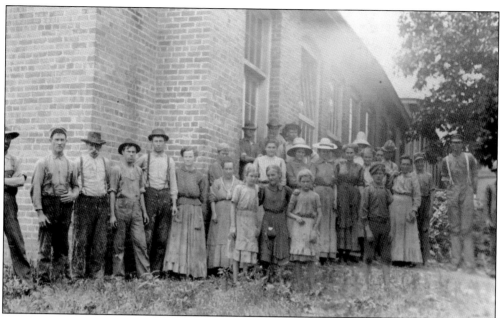

WORKERS AT COTTON MILL. The West Point Cotton Mill, which included both the mill proper and housing for the workers, was located on Old White Road, south of Mayhew Street. The mill operated under various owners from around 1901 through the 1950s. The first mechanized cotton mills were developed in England in the mid-1700s and later spread to New England and, eventually, to the South, where a ready supply of raw material and cheap labor was available. In the below photograph, school-age children work as spinners. The photographs were taken in May 1911 by L.W. Hine, a staff photographer for the National Child Labor Committee. Hine's collection of photographs documented the need for laws to safeguard child labor and general worker safety. (Both, courtesy of the Library of Congress.)

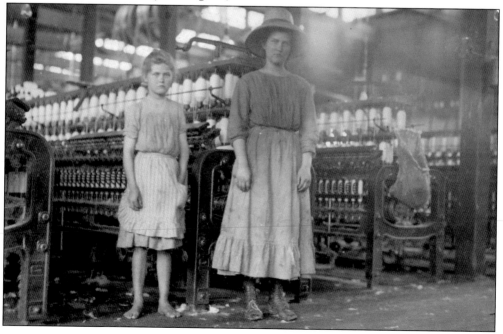

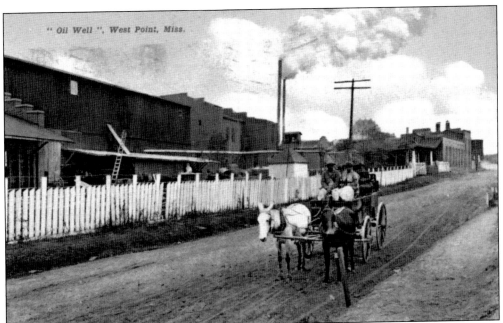

CLAY COUNTY COTTON OIL COMPANY. Located on the east side of North Division Street, the Clay County Cotton Oil Company engaged in making cottonseed oil from cottonseed, a by-product of ginning. Later, a portion of this plant was turned into the West Point Ice Company. This postcard, dated to the 1910s, is erroneously labeled "Oil Well." The brick gin house is at far right.

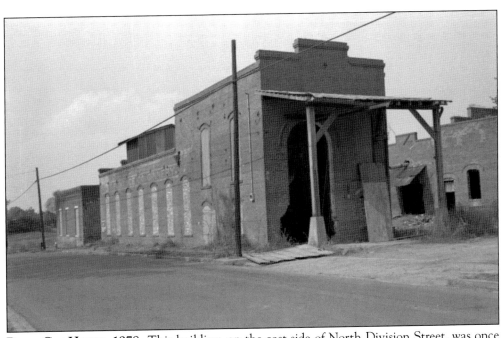

BRICK GIN HOUSE, 1978. This building, on the east side of North Division Street, was once part of the Clay County Cotton Oil Company (see above photograph). It later served as part of the West Point Ice Company and Ginnery, whose name appears on the side of the building. (Photograph by Jack Elliott.)

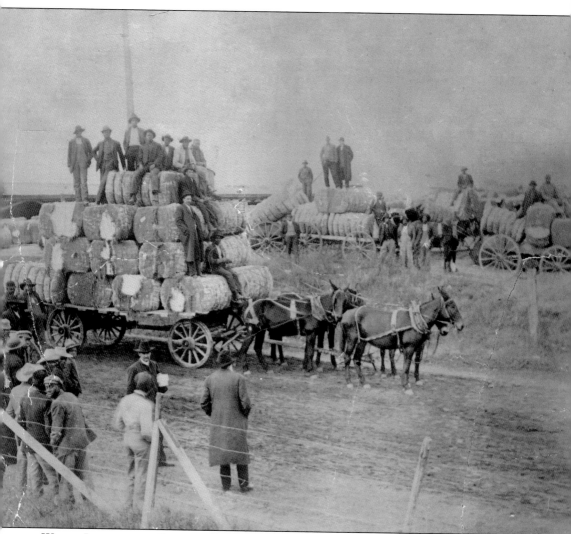

WAGON LOADED WITH COTTON. A mule-pulled wagon is loaded with freshly ginned cotton bales at the West Point Cotton Yard on West Main Street. There appear to be about 23 bales; at about 500 pounds per bale, the load weight would be about 12,000 pounds, or six tons. Mules were the choice draft animal for pulling wagons and plows.

Four

RAILROADS AND DEPOTS OF WEST POINT

While waterways were initially the primary transportation routes connecting northeast Mississippi with the outside world, railroads played an increasingly important role. The first railroads were developed in England in the 1820s as a spin-off from the Industrial Revolution. However, it was not until the 1850s that they first reached north Mississippi, being constructed out of port cities such as New Orleans, Memphis, and Mobile. The latter city was the primary sponsor of the Mobile & Ohio Railroad, and the railroad in turn led to the birth of West Point as a railroad town.

The survey of the Mobile & Ohio Railroad reached the intersection with what was then known as the Upper Prairie Road or the Columbus to Houston Road (today's Main Street/Highway 50), the site that would become West Point, two or three years before the railroad was constructed to that point. In May 1855, Moses Jordan, a local planter who owned the land chosen for the depot site, donated a 400-foot-by-1,400-foot parcel to the railroad to serve as its depot grounds. There, its depots were located, and its abundance of acreage served various uses. In that same year, Jordan instigated the survey of a town plat around the depot grounds by Miles Hasford, division engineer for the Mobile & Ohio. Over the decades, as the town grew, the depot grounds served as an open focal space for various activities.

In the early 20th century, the railroad sold or donated portions of the depot grounds, on which features were constructed, including the city hall (1909), the Carnegie Library (1915), the swimming pool (1925), the American Legion hut (1927), and others. Although much of these grounds are built on today, the reason West Point has so much open park space adjacent to the downtown area is because the Mobile & Ohio prevented its development by private interests.

With the coming of two more railroads, constructed along the western edge of the central business district in the 1880s, West Point became a rail crossroads. While these new lines became centers of activity in their own right, they did not play as important a role as the Mobile & Ohio in the town's history.

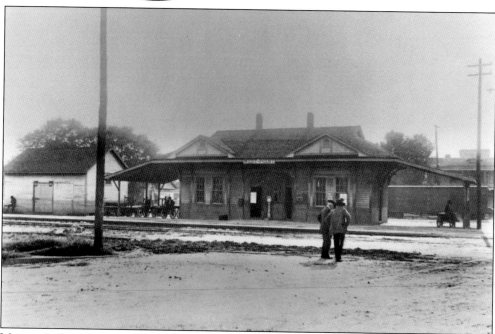

"THE FATHER OF WEST POINT." In 1855, after the Mobile & Ohio Railroad located a depot site on the northwest corner of his farm, Moses Jordan (1820–1865) instigated the survey of a town plat around the depot grounds. By the time the railroad was completed to West Point in late 1857, the town was beginning to develop. This drawing of Jordan dates to around 1860. (Courtesy of Preston Williams.)

MOBILE & OHIO DEPOT, 1914. Completed on December 7, 1889, this Mobile & Ohio passenger depot was not the first one. It may have been the third. The first station, completed in March 1858 and burned by Union troops in 1864, was located in the middle of Broad Street. The West Point central business district developed around the first station.

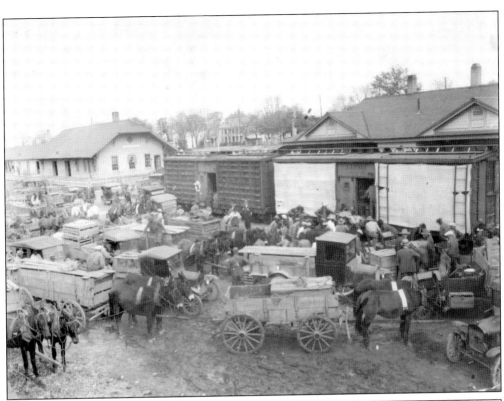

SHIPPING DAY. A traffic jam (both automotive and mule-driven) occurs on the Mobile & Ohio Railroad depot grounds. Farmers line up for Swift & Company's shipping day in the 1920s. It appears that the farmers are bringing chickens for sale. The passenger depot is on the right, behind the boxcars. The freight depot is on the left. Broad Street runs between the two.

MOBILE & OHIO DEPOT GROUNDS. The depots, both freight and passenger, are to the right, alongside the tracks. Commerce Street and its businesses are to the left. In the foreground are stacks of hewed timbers. City hall, in the distance, was apparently still under construction in 1909, because the clock tower had not yet been erected.

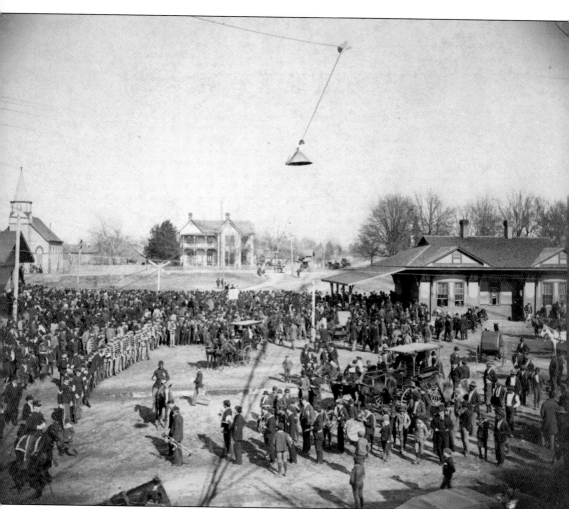

WAITING FOR BRYAN. Eagerly awaiting the arrival of presidential candidate William Jennings Bryan, who was scheduled to speak at the Southern Female College in West Point, a crowd gathers along Broad and Commerce Streets near the Mobile & Ohio passenger depot (right) and the freight depot (left). The first building used by the Cumberland Presbyterian Church is behind the freight depot. (Courtesy of West Point–Clay County Museum.)

WILLIAM JENNINGS BRYAN. Opening his 1898 southern tour, presidential candidate William Jennings Bryan (right of center, without hat) of Nebraska arrived in West Point on February 28, 1898. The event was known as "Bryan Day." He is depicted here outside the Mobile & Ohio depot. His visit drew people from all over north and central Mississippi who came to hear him speak at the Southern Female College in West Point.

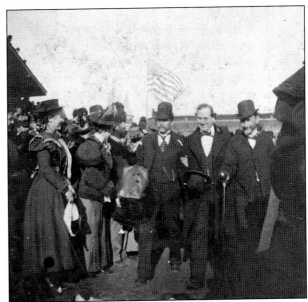

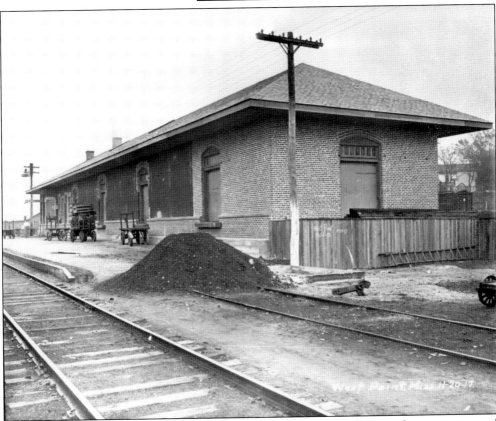

ILLINOIS CENTRAL DEPOT, C. 1917. The depot in this east-facing photograph was constructed about 1884 as part of the new Canton, Aberdeen & Nashville Railroad. The station was later acquired by the Illinois Central Railroad. Used today as the Sam Wilhite Transportation Museum, it is the only remaining depot in West Point. (Courtesy of Elizabeth Calvert.)

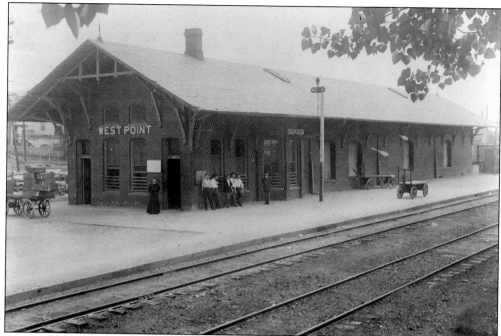

ILLINOIS CENTRAL DEPOT. The front fifth of the building housed the office and passenger depot, while the rear four-fifths served as the freight depot. The small wagons, known as drays, were used for conveying freight. Notice the gable roof, which was later rebuilt into a hipped roof. This photograph looks to the south. (Courtesy of Edwin Ellis.)

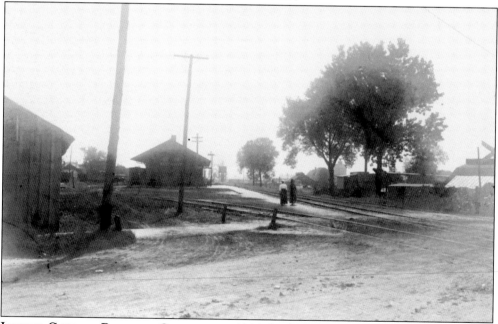

ILLINOIS CENTRAL RAILROAD CROSSING, C. 1914. Looking southwest from the north side of Main Street, Howard Tees photographed this view of the Illinois Central depot. Tees captured the railroad crossing on Main Street and the depot grounds at a quiet time. Note the unpaved surface of Main Street in the foreground.

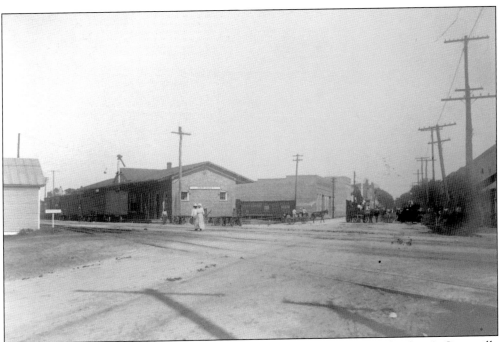

MAIN STREET, C. 1914. The tracks of the Southern Railroad (later the Columbus & Greenville Railway) are in the foreground in this east-facing photograph. The Southern depot is on the left side of the street. Murff Row is on the right side of Main Street. In the distant background is the center of West Point's central business district. (Photograph by Howard Tees.)

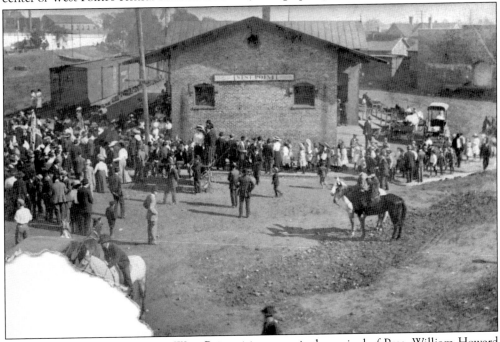

WAITING FOR PRESIDENT TAFT. West Point citizens await the arrival of Pres. William Howard Taft in October 1909 at the Southern Railroad depot on Main Street. Taft passed through West Point on his way to a speaking engagement in Columbus and stopped to greet the people.

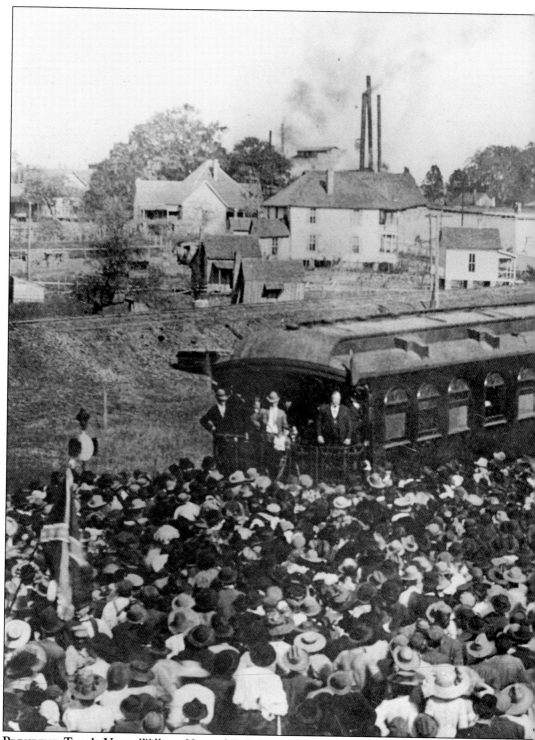

PRESIDENT TAFT'S VISIT. William Howard Taft (rear of train, without hat) was greeted with cheers and the waving of flags. A Republican, he remarked that he greatly appreciated the warm reception, considering the fact that the people of West Point had so little to do with his election.

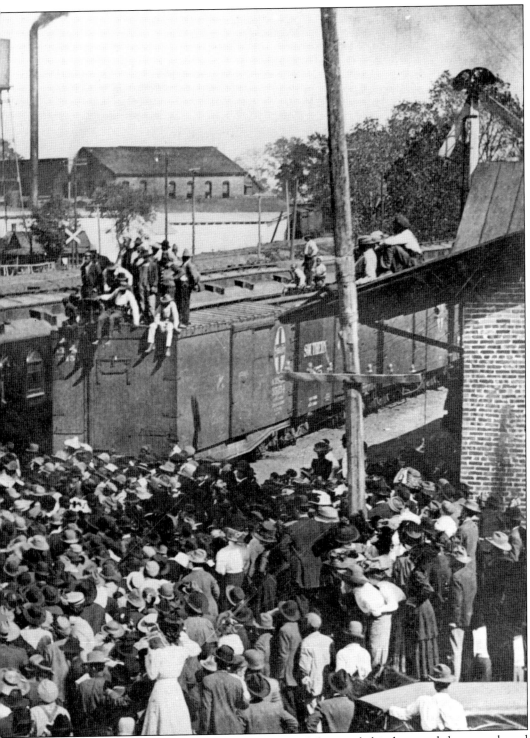

After a brief talk, he boarded his train and departed, leaving behind a crowd that was pleased to have seen a president of the United States. This was the only occasion of a sitting president visiting West Point.

SOUTHERN (COLUMBUS & GREENVILLE) DEPOT. This southwest-facing photograph shows the loading dock in the foreground and a boxcar on the rails to the side. The depot was located on the north side of Main Street, across from Murff Row. Part of Murff Row is visible in the background. (Courtesy of the Sam Wilhite Transportation Museum.)

Five

THE WEST POINT CENTRAL BUSINESS DISTRICT

The survey of the West Point depot grounds and the town plat laid out the first streets, providing the basic framework around which the town developed. The center of commerce was along what was originally called Front Row, later appropriately named Commerce Street. The street connected the main east-west corridor, Main Street, to the north with the Mobile & Ohio depot to the south. The earliest commercial buildings developed on the west side of Commerce Street, facing the railroad. As the central business district expanded, commercial buildings were constructed on the east side of Commerce Street as well as on Main Street, Jordan Avenue, and Court Street.

The businesses included retail stores—dry goods, groceries, hardware, and drugs—as well as hotels, livery stables, blacksmith shops, and offices of doctors and lawyers. They provided goods and services for town dwellers, and, more importantly, for those from the rural areas of the county, the farmers, whose income provided the economic base for West Point.

The first commercial buildings were primarily of frame construction, and as stores were erected side-by-side, the central business district, as was common in early towns, became one big tinderbox awaiting a fire. A blaze in April 1872 burned almost every building on the west side of Commerce Street. They were rebuilt using brick construction, which made them much more fire-resistant. Despite this effort, another major fire broke out in 1892, burning the entire block encompassed by Jordan Avenue and Commerce, Broad, and Court Streets. Among the losses were numerous brick stores and office buildings, along with the city hall, the Methodist church, and the Carothers livery stable.

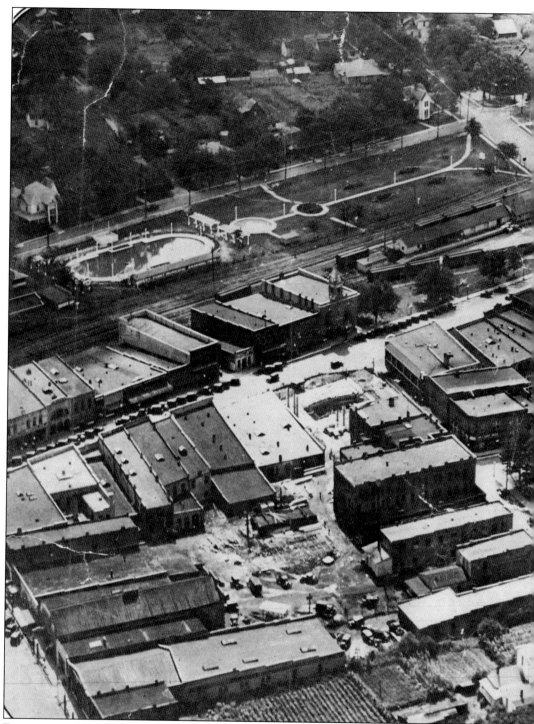

DOWNTOWN, 1929. Taken from an airplane, this photograph offers a panoramic view of West Point's central business district, revealing the organization of the town around the railroad. Shown are the Mobile & Ohio Railroad and the depot grounds, which included the passenger and freight depots. Also visible are city hall (above and left of center), the swimming pool, the Carnegie

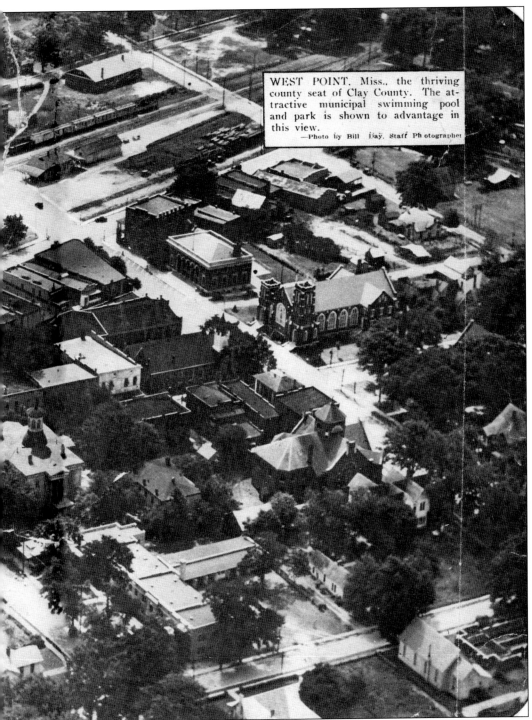

WEST POINT. Miss., the thriving county seat of Clay County. The attractive municipal swimming pool and park is shown to advantage in this view.
—Photo by Bill Day, Staff Photographer

Library (upper center), and the American Legion hut (right of library). Commerce Street (the old Front Row) runs parallel to the railroad. The Holt Hotel, on the corner of Commerce Street and Jordan Avenue, had just been demolished in preparation for the building of the Henry Clay Hotel. The old courthouse is just below center, one block west of Commerce Street.

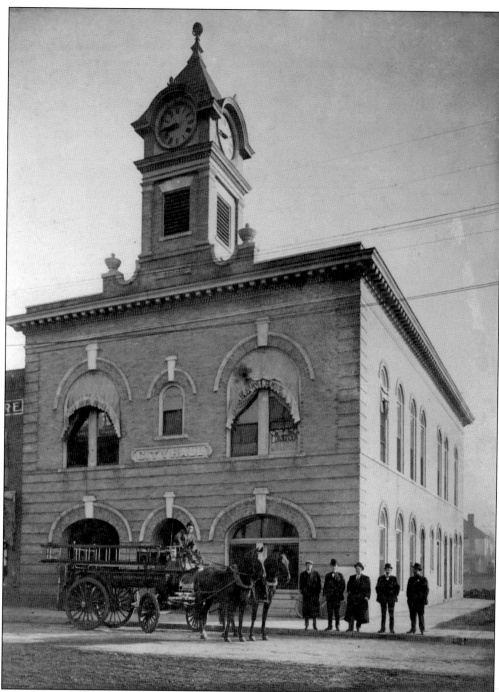

WEST POINT CITY HALL, C. 1910. In 1909, after the city had acquired a lot on the Mobile & Ohio Railroad depot grounds, city hall was constructed by J.H. LaRue of West Point based on a design by architect Burt Stewart of Meridian. This two-story brick structure with a clock tower was built to serve specifically as West Point's city hall. The unidentified men standing on the right are probably members of the city government. The man on the fire wagon is Henry Hardy, who later served as city fire chief. (Courtesy of Jack Elliott.)

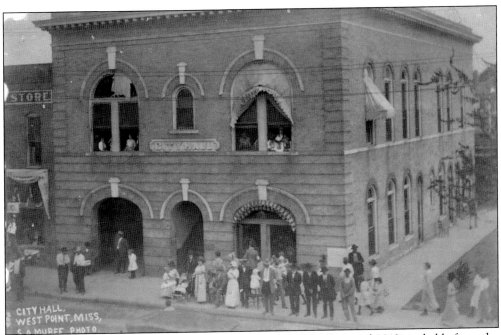

CITY HALL CROWD. The photograph was taken by S.A. Murff around 1910, probably from the roof of a store across the street. People appear to be congregating for an unknown event.

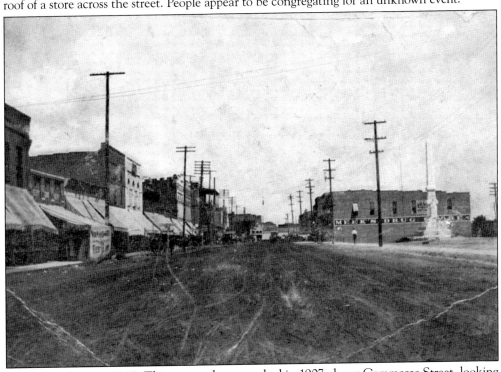

COMMERCE STREET, 1907. This postcard, postmarked in 1907, shows Commerce Street, looking north through West Point's central business district. The Confederate Monument on the right had been erected that same year, but city hall had not yet been built. The third-story porch of the Holt Hotel can be seen in the distance on the left side of the street.

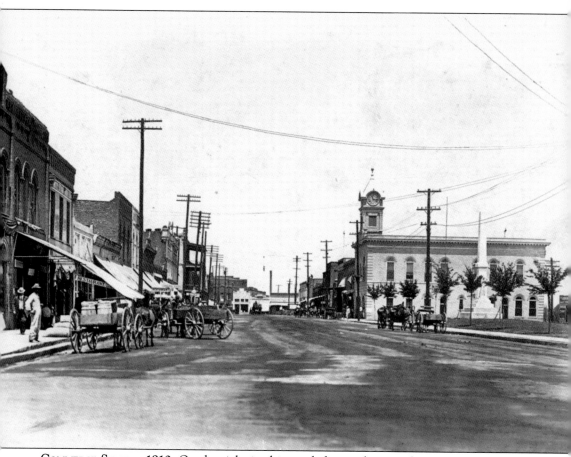

COMMERCE STREET, 1910. On the right in this north-facing photograph are two landmarks of downtown West Point: the newly constructed city hall and the recently established Confederate Park and Confederate Monument, which represented the first component of what developed into the town's large central park. Wagons are parked along the street, waiting to pick up merchandise.

CONFEDERATE MONUMENT, C. 1912.
Located just south of the present-day city hall, the Confederate Monument was erected in 1907 through the initiative of the John M. Stone Chapter of the United Daughters of the Confederacy on property donated by the Mobile & Ohio Railroad. Initially called Russell Park, after Col. E.L. Russell, president of the Mobile & Ohio, this parcel of land was later named Confederate Park. (Courtesy of Kay Manzolillo.)

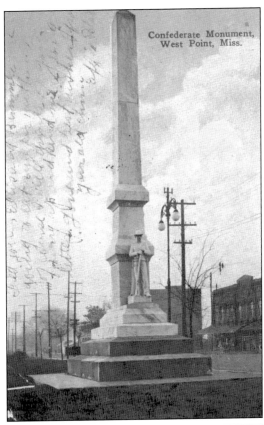

Confederate Monument, West Point, Miss.

COMMERCE STREET, 1920S. This photograph looks across Commerce Street to the northwest, toward Jordan Avenue. On the right side of Jordan Avenue is the three-story Holt Hotel. All of the buildings in this photograph were demolished in the late 1920s. The Henry Clay Hotel now stands on the site where the Holt Hotel once stood. Note the truck and the automobiles, which were quickly replacing mules and wagons.

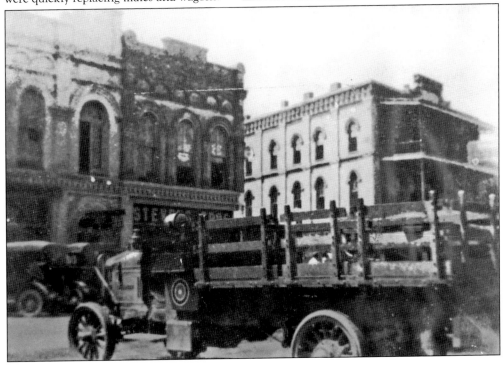

DRUGSTORE, C. 1905. H.E. "Ed" Williams stands in front of the Ellis Drugstore, or its successor, the Ivy-Deanes Drugstore, on Commerce Street. The drugstore, on the ground floor of the Holt Hotel, later became Rose Drugstore. Williams, the father of the late historian Ruth White Williams, leased and operated the soda fountain located inside the store.

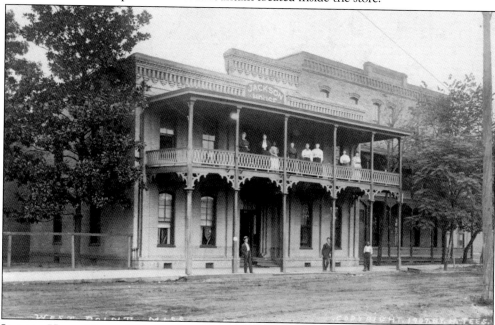

JACKSON HOUSE HOTEL. This hotel was located at the corner of Broad and Commerce Streets, a location clearly selected to take advantage of travelers disembarking at the Mobile & Ohio depot, just across Commerce Street to the east. By the 1920s, the name was changed to the Commercial Hotel. The brick structure was demolished in the 1960s and replaced with the Bank of West Point (now BancorpSouth).

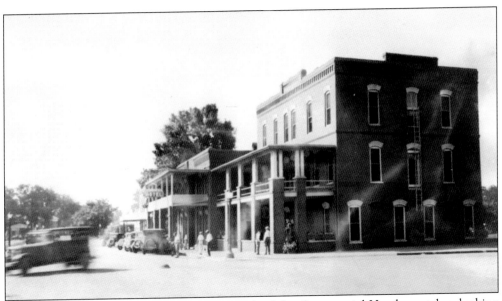

COMMERCIAL HOTEL, C. 1927. This photograph of the Commercial Hotel was taken looking south down Commerce Street. Strategically located opposite the Mobile & Ohio passenger depot, the hotel, known for decades as the Jackson House, was a thriving business. The broad verandas provided a place for guests to escape the heat in an era before air-conditioning. (Courtesy of Jack Elliott.)

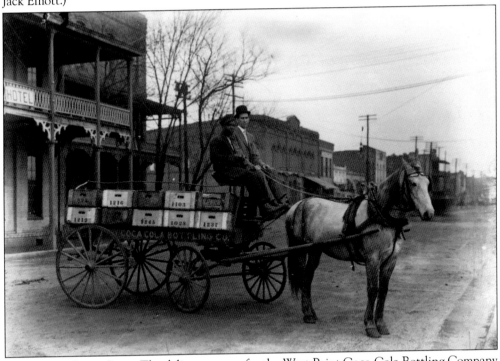

DELIVERING COCA-COLA. The delivery wagon for the West Point Coca-Cola Bottling Company pauses in front of the Jackson House Hotel (left). The photograph was taken soon after the founding of the company in 1906. The hotel is at the corner of Commerce and Broad Streets. (Courtesy of Carolyn Atkins.)

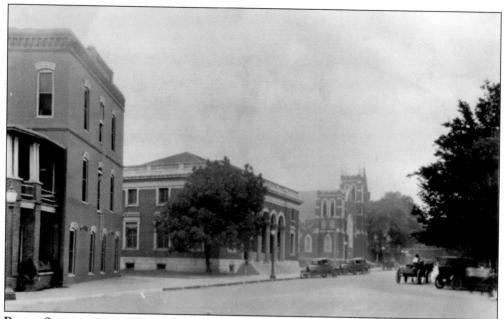

BROAD STREET, 1920s. This west-facing photograph was taken from Commerce Street. Seen here are, from left to right, the Commercial Hotel, originally known as the Jackson House; West Point Post Office, whose cornerstone gives a construction date of 1912; and the First Methodist Church, built between 1920 and 1922. (Courtesy of West Point–Clay County Museum.)

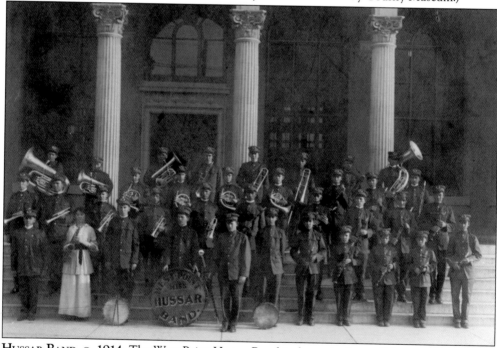

HUSSAR BAND, C. 1914. The West Point Hussar Band is shown in front of the newly completed post office. The band, founded in 1913 under Prof. A.H. Thrall, provided free weekly concerts for the community. The year of its founding, the band traveled to Jacksonville, Florida, where it played at the Confederate reunion and won first honors.

HOLT HOTEL, C. 1900. This hotel stands on the corner of Commerce Street and Jordan Avenue. The landmark was constructed after its predecessor, the Central Hotel, burned down in a fire that consumed much of the central business district in 1872. Soon after the demolition of the Holt, the Henry Clay Hotel was constructed on the site in 1929–1930.

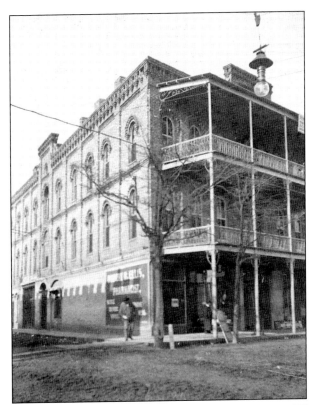

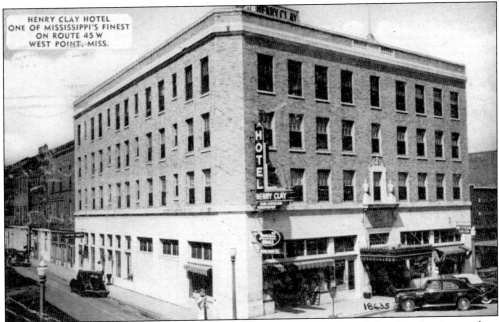

HENRY CLAY HOTEL, C. 1940. This hotel was a West Point landmark for decades. Located on the northwest corner of Jordan Avenue and Commerce Street, it was constructed in 1929–1930 on the site of the old Holt Hotel. Today, it is operated by the United Methodist Church Senior Services as a retirement home. (Courtesy of Elizabeth Calvert.)

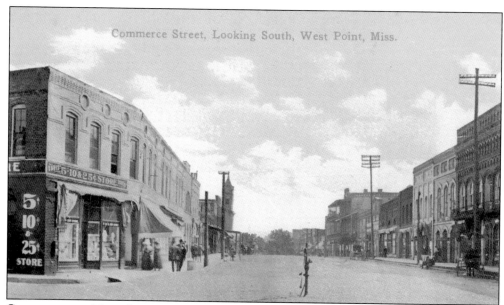

COMMERCE AND MAIN STREETS, C. 1910. This postcard view looks from Main Street, south on Commerce Street. The water pump is in the middle of the intersection, and Davis 5-10 & 25¢ Store is on the left. In the distance is the clock tower of the newly constructed city hall. The three-storied porches of the Holt Hotel are at right. (Courtesy of Edwin Ellis.)

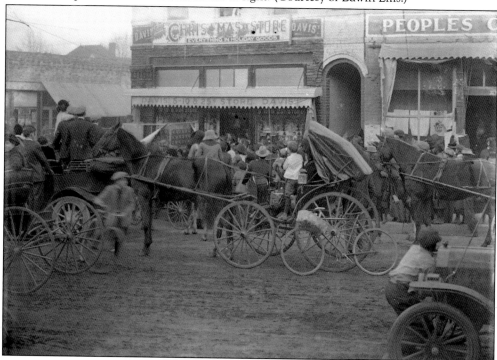

CONGESTION AT COMMERCE AND MAIN STREETS, C. 1910. The streets are clogged with traffic at the intersection of Commerce and Main Streets, viewed to the east. Horses were still the most common mode of transportation, and automobiles were just beginning to appear. On the corner, Davis 5-10 & 25¢ Store advertises Christmas sales. (Courtesy of Marcia Phyfer.)

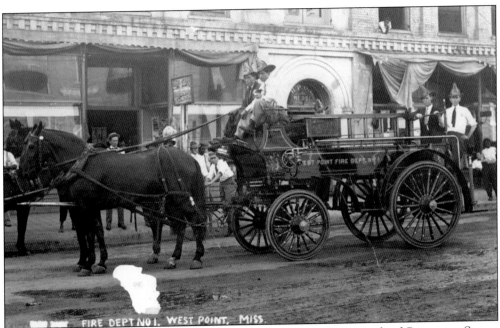

WEST POINT FIRE WAGON, C. 1910. The wagon is stopped on the west side of Commerce Street, just south of Jordan Avenue. At left in the front seat is fireman Jabez East, and standing on the left rear is Henry Hardy. Note the reflection of city hall in the windows on the left. A window right of center reads "B.P.O.E. [Benevolent and Protective Order of Elks] No. 951." (Courtesy of West Point–Clay County Museum.)

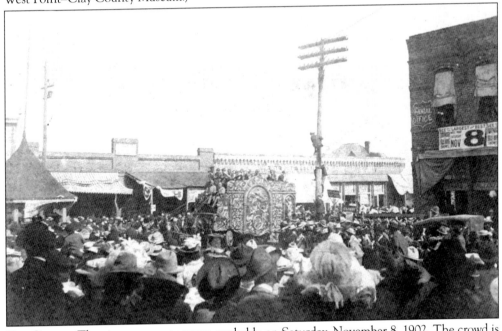

THE CIRCUS. The circus comes to town, probably on Saturday, November 8, 1902. The crowd is gathered in anticipation as an ornate circus wagon turns off Main Street and onto Commerce Street. Note the boys who have climbed a pole for a better view. The arrival of a circus was a major festive occasion, bringing in spectators from all over the county.

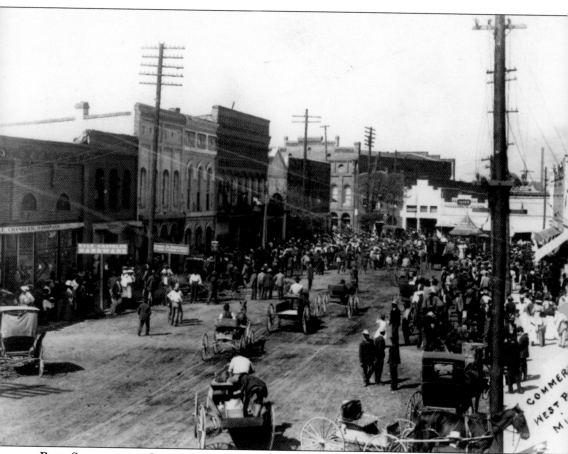

BUSY SATURDAY ON COMMERCE STREET, C. 1907. This northwest-facing photograph, taken by Howard Tees, shows Commerce Street, with Main Street in the background. This scene was typical for a Saturday, when so many people came to town to shop. The conical-shaped roof at the intersection of Commerce and Main Streets covered one of the town's public wells.

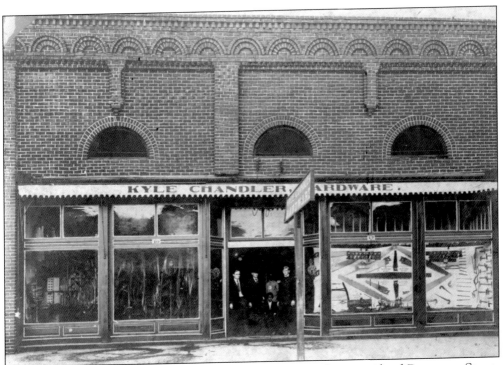

KYLE CHANDLER HARDWARE STORE, C. 1910. This store, on the west side of Commerce Street, was owned and operated by Kyle Chandler Sr. (1879–1960). In 1920, he founded the Kyle Chandler Insurance Agency. The building was later occupied by Davis 5-10 & 25¢ Store, then by F.W. Woolworth and Company, and then by Café Ritz.

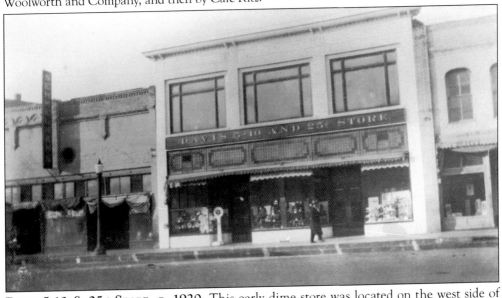

DAVIS 5-10 & 25¢ STORE, C. 1920. This early dime store was located on the west side of Commerce Street. The building had previously been used by Kyle Chandler Hardware. The facade was rebuilt to produce the appearance seen here. The building was subsequently used by another dime store, F.W. Woolworth and Company, an international chain. (Courtesy of West Point–Clay County Museum.)

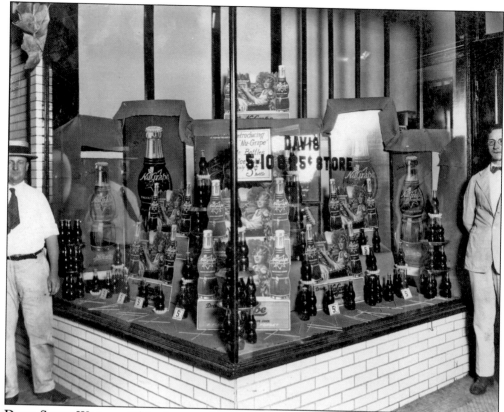

DAVIS STORE WINDOW. This photograph of the display window of Davis 5-10 & 25¢ Store on Commerce Street was taken soon after the soft drink Nu-Grape was first bottled in 1921, as indicated by the display. On the left is Ed Watson, probably a clerk. At right is R.C. Davis, store proprietor and West Point mayor from 1936 to 1946.

KYLE HOUSE HOTEL, c. 1910. This hotel was located on the north side of Broad Street, one lot west of Court Street. Built in 1905, it operated under the name Kyle House until as late as 1925. It was later known as the Brown Hotel. Last used as the Masonic lodge, it was demolished soon after a new lodge was built in 1979.

CAROTHERS, INC., 1978. Carothers, Inc., was a Dodge-Plymouth dealership with a service station and garage. This business was established around 1946 by James and R.C. Carothers. The original establishment here was founded in 1923 as Reid & Deas, operated by Jerome Reid and Ernest Deas. The building depicted was constructed between 1925 and 1941 by Reid and Deas. The Bryan Reading Park occupies the site today. (Photograph by Jack Elliott.)

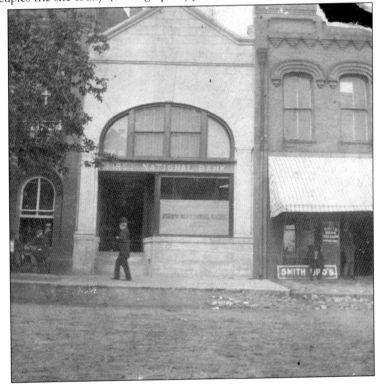

FIRST NATIONAL BANK, c. 1910. The bank began in 1872 as G.W. Foster & Company, which became Stockard, Bonner & Company in 1877, before becoming First National Bank in 1888. Later, it moved to the Commerce Street location seen here. The institution was eventually absorbed by Cadence Bank.

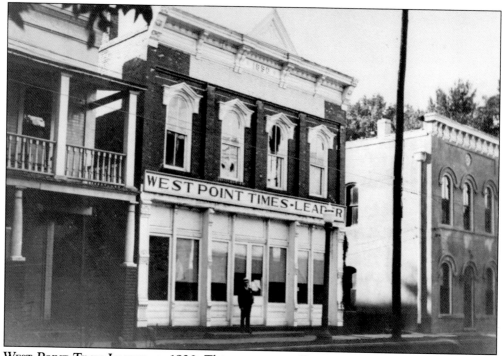

WEST POINT TIMES-LEADER, C. 1930. This newspaper office on Court Street was constructed in 1890 and served first as the post office before housing the office for the *West Point Leader* newspaper. In 1928, the Edgar Harris family moved to town and purchased the *Leader* and the *Times Herald*, consolidating them into the semiweekly *West Point Times-Leader*. It became the *Daily Times Leader* in 1931. (Courtesy of Jack Elliott.)

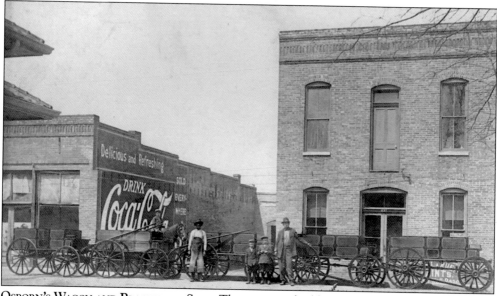

OSBORN'S WAGON AND BLACKSMITH SHOP. The one-story building on the left housed the Osborn Wagon and Blacksmith Shop in 1918. The two-story building on the right was a boardinghouse in 1910. Note in the right foreground the top of the iron fence on the northwest corner of the courthouse lot. (Courtesy of West Point–Clay County Museum.)

56

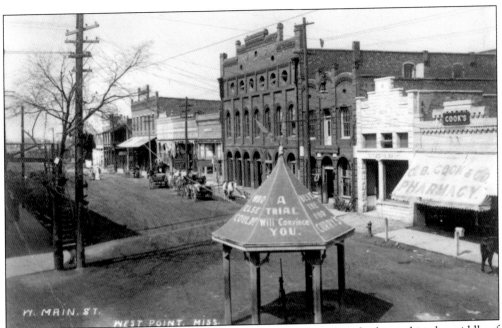

WEST MAIN STREET, C. 1905. The water pump with its covered roof is located in the middle of the intersection of Main and Commerce Streets. Behind that is the tall Smith Building. Erected in 1885, it housed the West Point Opera House on its second floor. To the left and several doors west of the Smith Building is the tall building that for decades housed the Calvert Furniture Company. On the right is Cook's Drugstore.

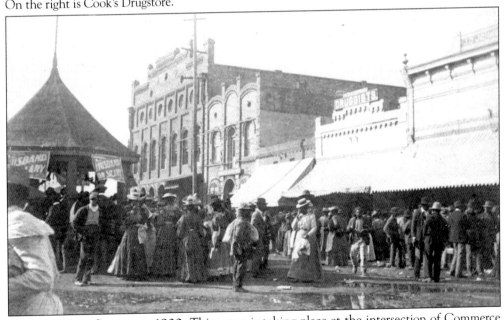

WELL ON MAIN STREET, C. 1900. This scene is taking place at the intersection of Commerce and Main Streets. The buildings are all on the north side of Main Street. On the left is the roof of one of the two public overflowing wells. The photograph was probably taken on a Saturday, given the number of people present. Historically, Saturdays were when people from rural areas flocked to town.

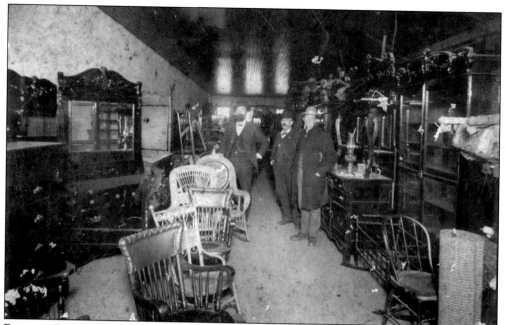

BEASLEY & CROUCH FURNITURE STORE, C. 1905. The partnership of A.A. Beasley and A.D. Crouch operated a large furniture store that featured an "Undertaking Parlor." The store was located on the north side of Main Street, in the two-story building now used by Mossy Oak. Soon after this photograph was taken, the business was purchased and operated by James V. Calvert as Calvert Hardware, which eventually became Calvert Funeral Home.

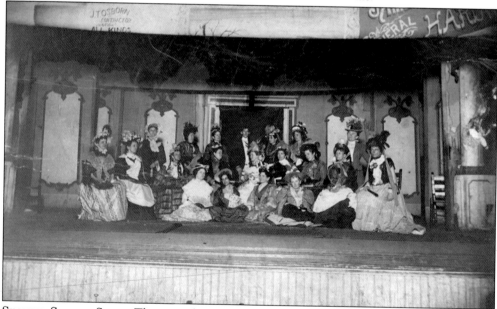

SINGING SCHOOL SHOW. The opera house was on the second floor of a commercial building constructed by B.F. Smith on the north side of Main Street around 1885. Opera houses were not used for opera but were instead intended for a variety of entertainments that would later be classified as vaudeville. Here, a Singing School Show performs at the West Point Opera House in the late 19th century.

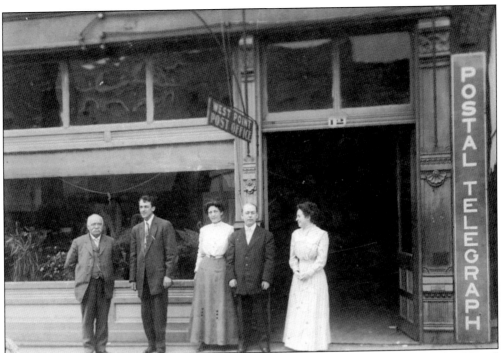

POST OFFICE, C. 1911. Standing in front of the West Point Post Office are, from left to right, Edward Dezonia (postmaster), Benson L. Myers Sr. (register clerk), Minnie Montgomery (stamps and general delivery), Claude Chamberlain (mailing clerk), and Alice Dezonia (assistant postmaster). Alice was Edward's daughter. Edward Dezonia served as postmaster from 1910 to 1913. The post office at this time was located on the north side of Main Street, in a building that is still extant.

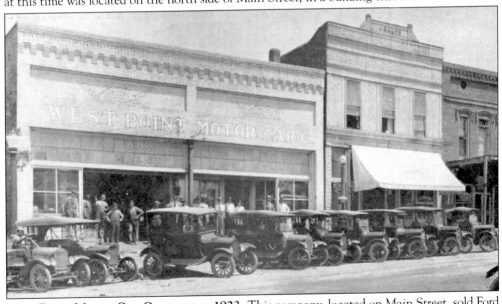

WEST POINT MOTOR CAR COMPANY, C. 1923. This company, located on Main Street, sold Ford automobiles. The business was established in April 1915 by Henry J. Applewhite and son John J. Applewhite. At the time of this photograph, a gallon of Crown gasoline sold for 17.5¢, and a quart of oil sold for 15¢. Soprano's Café and Billiards is currently in the building.

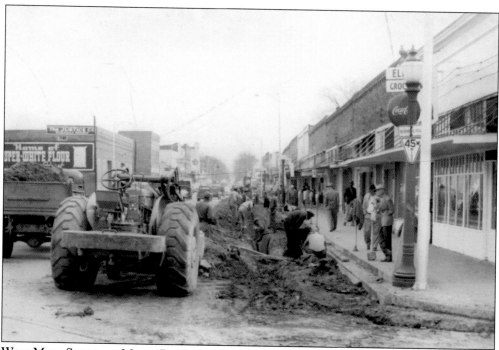

WEST MAIN STREET AT MURFF ROW, C. 1950. The city is apparently in the process of excavating a trench to lay pipes for utilities or for drainage. Murff Row is on the right. The Justice Company, a wholesale business, can be seen on the left and Elliott's Grocery on the far right.

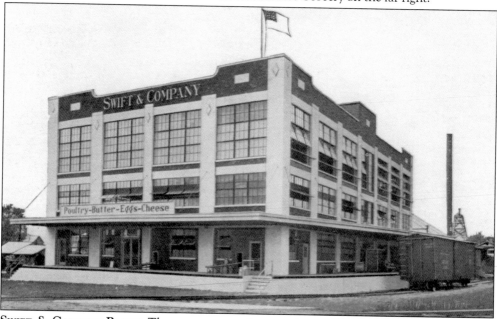

SWIFT & COMPANY PLANT. The company was in operation in West Point as early as 1910 on the east side of the Mobile & Ohio Railroad. About 1929, this much larger produce plant was constructed on Main Street. During the Depression and later, Swift provided a market for local farm and dairy products. An upper floor was later added to this plant in 1946. (Courtesy of Marcia Phyfer.)

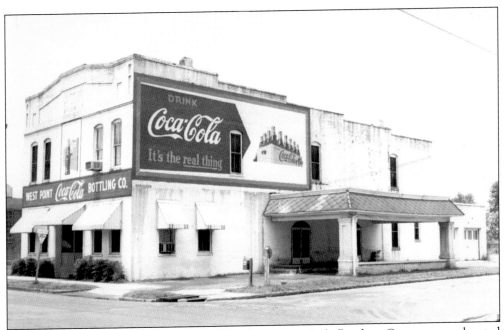

COCA-COLA BOTTLING COMPANY. The West Point Coca-Cola Bottling Company was located on the corner of Main and Stonewall Streets. The firm was established in West Point in 1906 and incorporated the following year. Initially located on Murff Row, it relocated by 1910 to the southwest corner of Critz and Cul-de-Sac Streets and constructed this building by 1918. Between 1959 and 1975, the company was consolidated with Northeast Mississippi Coca-Cola Bottling Company. (Courtesy of West Point–Clay County Museum.)

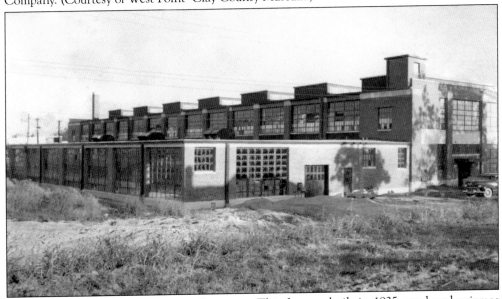

KNICKERBOCKER MANUFACTURING COMPANY. This factory, built in 1935, produced pajamas and other clothing. During the Depression and later, it provided much-needed jobs, primarily for women, many of whom moved into West Point from miles away. The factory employed as many as 376 people at its peak. It was demolished around 1986 and replaced with a Jitney Jungle grocery store.

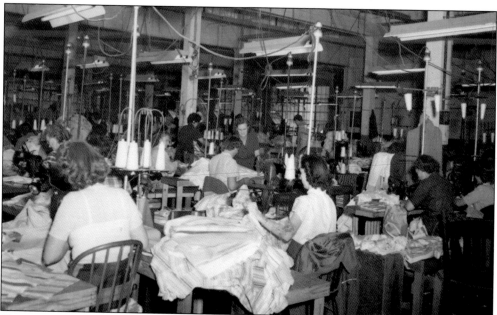

KNICKERBOCKER SEWING FLOOR. Women work on the sewing floor of the Knickerbocker Manufacturing Company, probably in the late 1930s. This company, located on West Main Street, was one of the earliest sources of nonfarm jobs for women and exemplifies the migration of the textile industry into the South. Many unmarried women moved to West Point from surrounding counties to work at Knickerbocker.

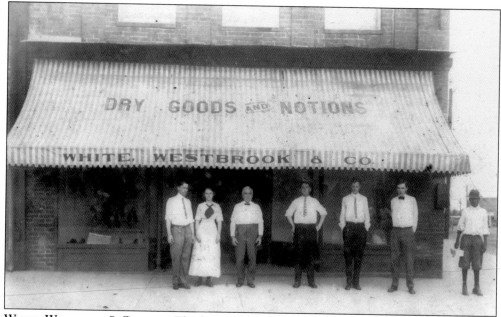

WHITE, WESTBROOK & COMPANY. This business, owned by W.G. White and W. Shelley Westbrook, was located in a two-story brick building on the southwest corner of Main and Commerce Streets, formerly the store of B.F. Robertson & Company. The building was demolished to make way for Pryor's Department Store, which later became McGaughey's Department Store. Today, after massive renovations, it is part of Cadence Bank. This photograph was taken in the early 20th century.

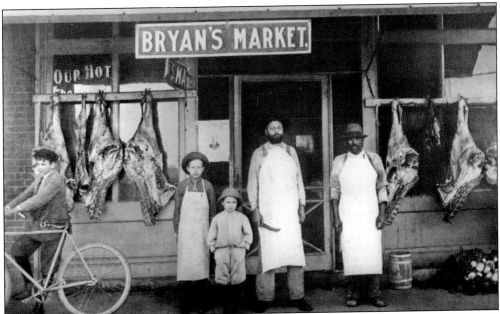

BRYAN'S MEAT MARKET. The proprietor, J.C. Bryan, stands at center with a knife in his hand in front of Bryan's Meat Market. Later, Bryan Brothers Packing Company was founded by two of his sons. A page hanging in the window reads "War! War! War!," suggesting either a 1914 or a 1917 date. The market was located in the second building from the west end of Murff Row. (Courtesy of George W. Bryan.)

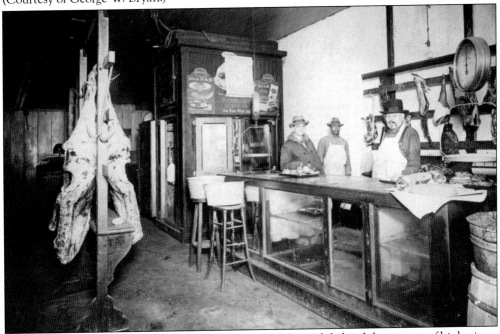

INTERIOR OF BRYAN'S MARKET, C. 1920. J.C. Bryan (right) stands behind the counter of his business on Murff Row. Note the fresh meat hanging unrefrigerated in an era before air-conditioning. The slaughterhouse was south of town on property that became Bryan Brothers and, later, Bryan Foods.

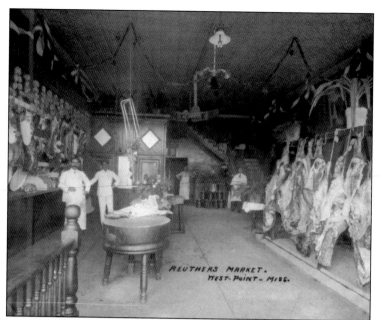

REUTHER'S MARKET, c. 1910. As seen here, Reuther's Market specialized in selling meat. The business was located in a two-story building on the west side of Commerce Street, south of the Jackson House Hotel. It was founded probably between 1870 and 1880 by Frank Reuther (1848–1914), a native of Germany. Reuther (left) stands with his sons Ed (second from left), Fred (center, rear), and Lamar.

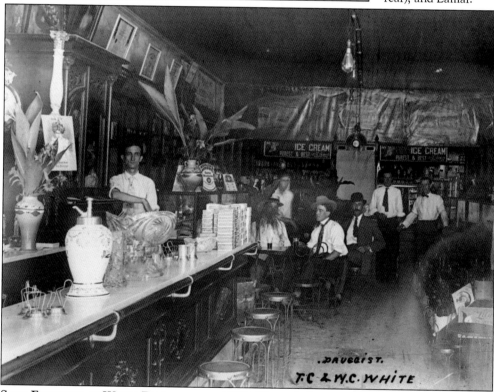

SODA FOUNTAIN AT WHITE DRUGSTORE, c. 1910. The soda fountain in the rear of the drugstore of T.C. and W.C. White is shown here. The business was established in the 1860s and operated until about 1916. Cox's Drugstore was opened here in the 1920s and continued in operation for decades. Note the advertisement for ice cream in the rear. Soda fountains were usually found in drugstores in the late 19th and early 20th centuries. (Courtesy of Marcia Phyfer.)

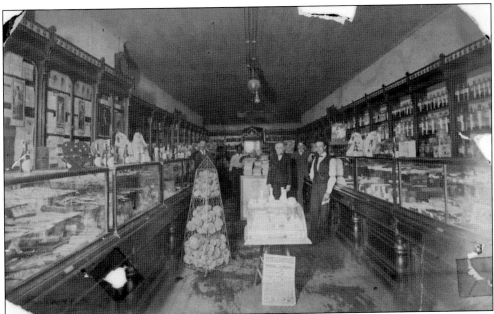

WHITE DRUGSTORE, 1914. T.C. and W.C. White's drugstore was located on the west side of Commerce Street, on a lot that was used for over a century as a drugstore. The last such establishment was Cox's Drugstore, from about 1927 through the 1970s. The site is currently used by Petal Pushers.

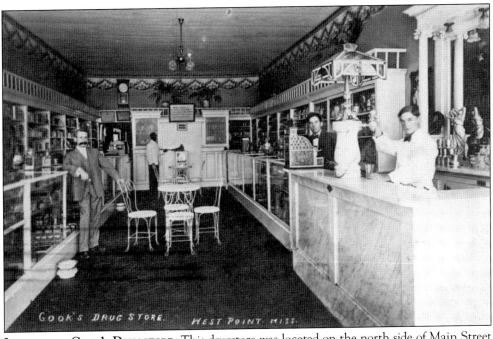

INTERIOR OF COOK'S DRUGSTORE. This drugstore was located on the north side of Main Street about 1910. Most businesses were long and narrow, with counters along either side. Drugstores carried merchandise other than drugs. Early on, most began to feature soda fountains, such as the one on the right.

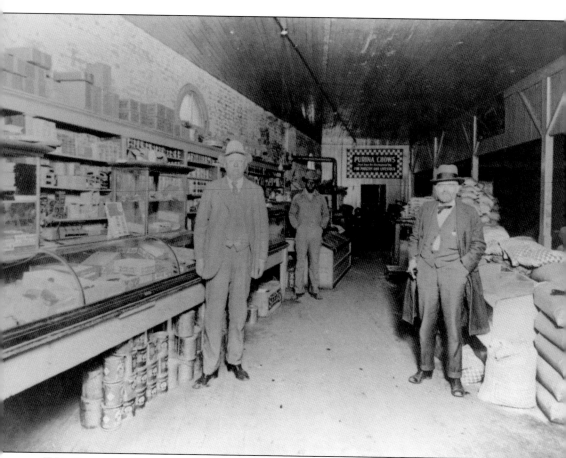

T.K. Chandler Feed Store, c. 1910. Thomas Kyle Chandler (left), the son of Confederate veteran A.M. Chandler, operated his feed store on the northwest corner of Broad and Commerce Streets for decades, until his death in 1939. His brothers Howard and Sterling operated the Chandler-Walker Mercantile in West Point. (Courtesy of Jack Elliott.)

Six

THE COURTHOUSE

The Clay County Courthouse in West Point is one of the town's most important buildings and the governmental center of the county. The symbolic importance of a courthouse was highlighted by William Faulkner in his novel *Requiem for a Nun* (1951) when he described the courthouse of his mythical Yoknapatawpha County as "the center, the focus, the hub; sitting looming in the center of the county's circumference . . . musing, brooding symbolic and ponderable, tall as cloud, solid as rock, dominating all: protector of the weak, judicate and curb of the passions and lusts, repository and guardian of the aspirations and the hopes."

Many towns were founded specifically as county seats, usually organized with a courthouse square at the center, with the business district growing up around the square. However, West Point, which was founded in the 1850s as a railroad town, was laid out with the railroad and depot at the center of the town's activity. West Point did not become a county seat until 1872, with the founding of Clay County (originally called Colfax County). Of course, there was no central square set aside for a courthouse, so a lot—not an entire block—was acquired a block back from Commerce Street, at the corner of Jordan Avenue and what would later become Court Street. Here the first courthouse was constructed and, later, the second (and present) courthouse was built.

The creation of Clay County meant that many rural residents did not have to travel as far to reach a courthouse. Placing the county seat at West Point insured a regular flow of visitors to the courthouse, which, in turn, increased the town's prospects for growth.

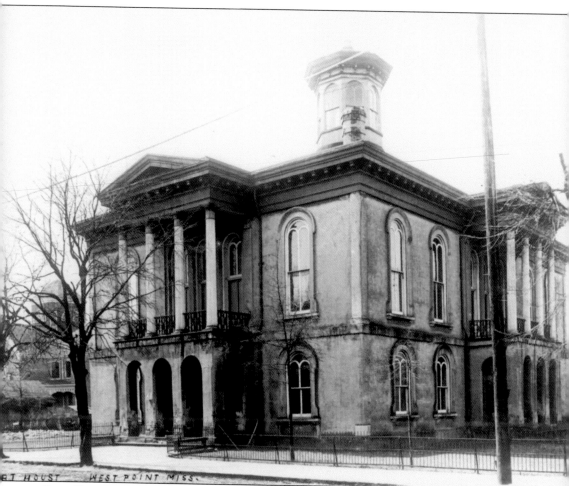

CLAY COUNTY COURTHOUSE, WEST POINT. The building was constructed between 1872 and 1874, soon after the 1872 establishment of Colfax (later Clay) County. The courthouse was built by contractors W.C. and W.S. White of West Point and was designed by architect Andrew J. Herod, who had been appointed state architect in 1865 by Gov. Benjamin G. Humphries. The courthouse, seen here in the first years of the 20th century, was located at the corner of Jordan Avenue and Court Street, the site of the current courthouse. The brick building was covered with plaster stucco. A brick jail and dwelling for the jail-keeper were erected off to its southwest corner and out of sight in this photograph. The old courthouse was demolished in 1956, at a time when replacing old buildings with new ones was in vogue. The building to the left and rear of the courthouse is the Cumberland Presbyterian Church, which was completed by 1898. (Courtesy of Marcia Phyfer.)

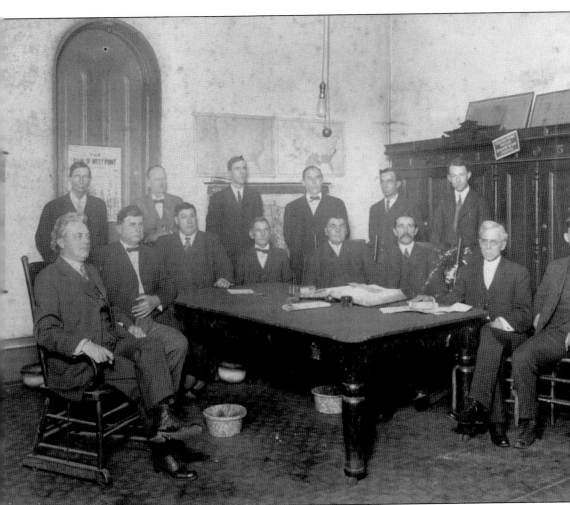

CLAY COUNTY OFFICIALS, 1916. Officials, both elected and appointed, gather in the board of supervisors meeting room in the courthouse. Shown are, from left to right, (seated) Charlie Wilsford (Beat 2 supervisor), Zack Ellis (Beat 1 supervisor), Mack Taylor (Beat 5 supervisor), W.T. McLemore (Beat 3 supervisor), John Gosa (Beat 4 supervisor), Lee Howard (chancery clerk), Frank A. Critz Sr. (board attorney), and Frank A. Critz Jr. (board attorney); (standing) L.W. Murphy (surveyor), A.H. Fox (circuit clerk), E.H. Walker (superintendent of education), W.H. Bryan (sheriff), Henry Kornegay (deputy sheriff), and Douglas Johnson (deputy chancery clerk). This photograph was probably staged to bring together all of the elected officials, along with appointed ones such as the surveyor, deputy clerk, deputy sheriff, and the board attorneys. These men were seldom gathered into the same room for meetings. Note the spittoons beneath the table.

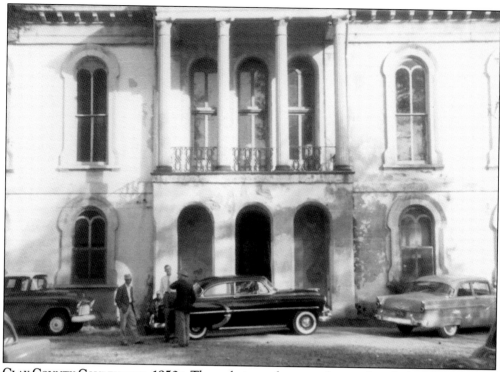

CLAY COUNTY COURTHOUSE, 1950s. These photographs were taken not long before the venerable landmark was demolished in 1956. The courthouse had the same distinctive porticoes on all four sides, of similar design to those found on the Lafayette County Courthouse in Oxford and the Marshall County Courthouse in Holly Springs. All three courthouses were built around the same time, in the years immediately following the Civil War. The photographs were taken on the same day, judging by the cars surrounding the building. The south facade is shown above. The photograph below shows, in part, both the south and east facades, with the latter facing Court Street. (Both, courtesy of West Point–Clay County Museum.)

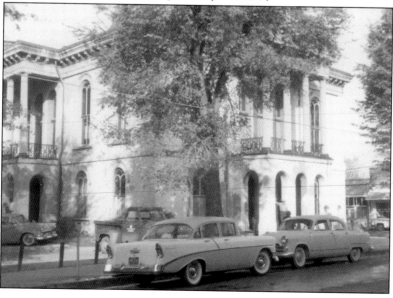

70

COURTHOUSE DEMOLITION.
The old courthouse is
in the process of being
demolished in 1956. The
magnificent structure
was deemed "unsound"
and razed in an era
when demolitions were
justified in the name of
"progress" and therefore
beyond question. As
demolition progressed,
it quickly became
apparent that, contrary
to opinion, the old
building was quite sound.

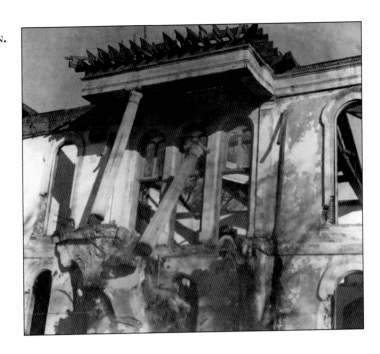

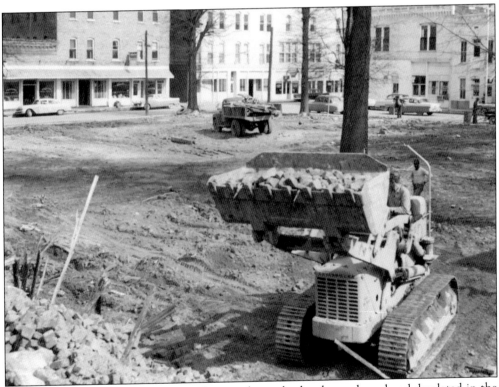

COURTHOUSE LOT CLEARED, 1956. The courthouse lot has been cleared and desolated in the march of "progress." Construction of the new courthouse would soon begin. Jordan Avenue is on the left, and Court Street on the right. The scene calls to mind the image of desolation from Lamentations 1:1, *Quomodo sedet solo civitas* ("How lonely the city stands").

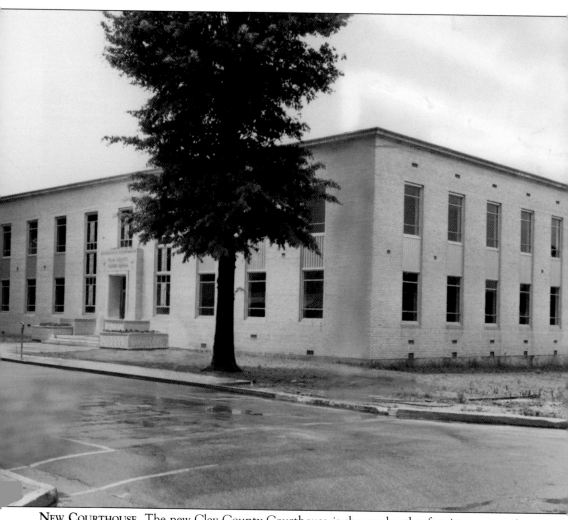

NEW COURTHOUSE. The new Clay County Courthouse is shown shortly after its construction in 1957. This building was a lackluster replacement for the classical beauty that had preceded it. The new structure was designed by Fort, White & Johnson, architects. The safe from the old courthouse was moved to the chancery clerk's office in the new building.

Seven

RESIDENCES, CHURCHES, AND SCHOOLS OF WEST POINT

As the business of the town grew, so too did the number of homes for its inhabitants. The first were probably simple, or vernacular, in character. A few of the more ornate homes were built in the Greek Revival style. Following the Civil War, the town continued to grow; newly freed blacks established residences in their own neighborhoods. The homes of the more affluent whites were constructed in many of the postbellum architectural styles, including Queen Anne, Italianate, and Second Empire. Because of West Point's development into the county seat, as well as its status as the most important town in the county, its architecture reflected much greater capital investment than was typically found in rural areas.

Other than residences, there were also churches and schools. The first churches were frame buildings erected before the Civil War. Slaves belonged to the same congregations as their masters. After the war, the freedmen began to establish their own churches. Many postbellum churches, especially in the white community, became much larger and tended to be constructed of brick and designed by architects.

In the late 19th century, schools for black and whites were opened. Sizes ranged from small frame structures to two-story brick buildings. Several impressive brick structures included George School, Lynch High School, Mary Holmes College, Southern Female College, and West Point Male Academy.

Furthermore, there were amenities, such as the city swimming pool, Confederate Park, and the Carnegie Library, all built on lots that were cut out of the large Mobile & Ohio depot grounds around which the town was centered.

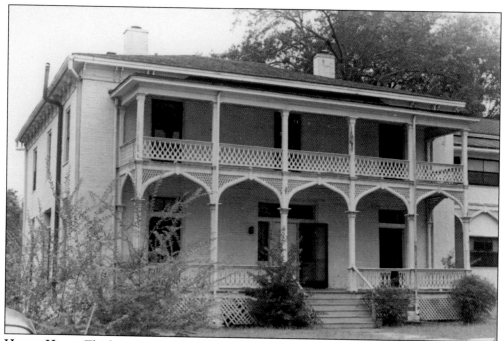

HENLEY HOUSE. This home was built in 1872 for Thomas A. Henley to serve as a hotel/boardinghouse. The brick structure is located on Commerce Street, south of the present post office. Instead of facing Commerce Street, it faces north, toward the former depot grounds that extended 1,400 feet north and south between Commerce and East Streets. In this way, the home faced the depot and disembarking passengers.

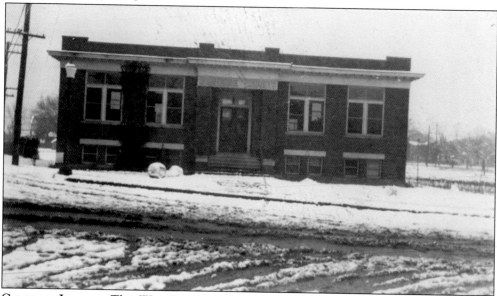

CARNEGIE LIBRARY. This West Point landmark was built in 1915 through a grant from the Andrew Carnegie Foundation on a lot cut from the Mobile & Ohio Railroad grounds. In 1952, the library became headquarters for the Tombigbee Regional Library. In 1978, it moved into its new building and is now known as the Bryan Public Library. The old building is currently used by the Growth Alliance.

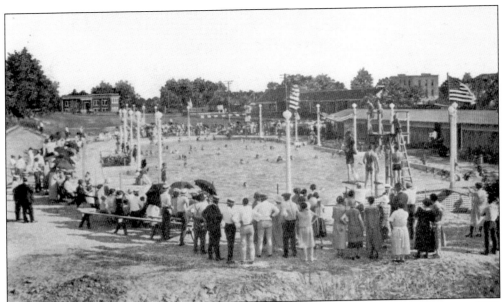

WEST POINT SWIMMING POOL. The West Point pool is shown shortly after its opening in 1925. The facility, sponsored by the New Century Club, the Rotary Club, and the city board, was constructed on land that had been part of the Mobile & Ohio Railroad grounds. Note the Carnegie Library in the left background and the Mobile & Ohio depots in the distance at right. The World War II Memorial now stands in the center of what had been the pool site. (Courtesy of Marcia Phyfer.)

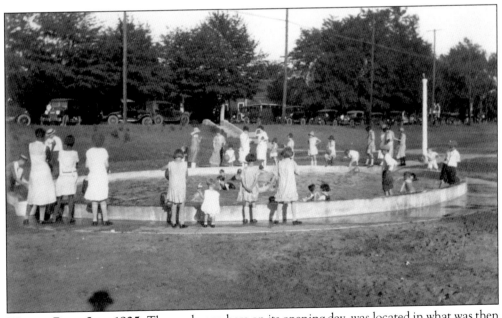

WADING POOL, JULY 1925. The pool, seen here on its opening day, was located in what was then known as City Park, now Sally Kate Winters Park. The view is to the southeast, with East Street in the background. This pool and the larger swimming pool to the north were constructed by A.D. Simmons Construction Company. The wading pool is still extant and used as a fountain.

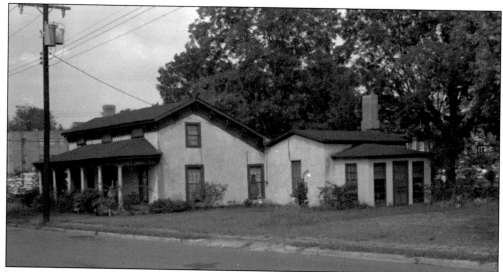

MANN-EAST-FRIDAY HOME, 1978. This house was constructed in the late 1860s of stuccoed brick with Italianate trim by Jabez Mann, a native of England and a merchant and ginner/miller. His daughter Margaret and her husband, William Thomas East, later occupied the home, as did their daughter Virginia and her husband, Curtis Roy Friday Sr. The home is now owned and maintained by the Community Foundation. (Photograph by Jack Elliott.)

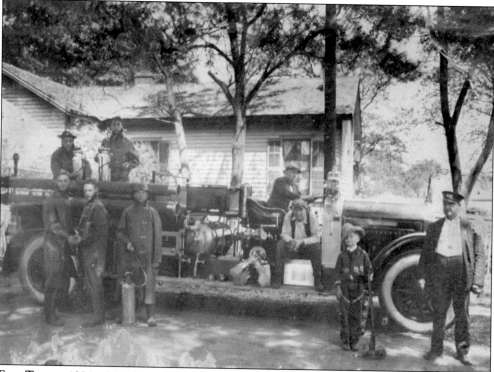

FIRE TRUCK, 1930s. Members of the West Point Fire Department gather around its fire truck. The fire department was organized in 1884. Horses were initially used to pull the fire engine until about 1929, when the first truck was acquired and came into service. The horses were then put out to pasture, literally. (Courtesy of West Point–Clay County Museum.)

FIRST BAPTIST CHURCH, 1978. The First Baptist Church congregation first met in 1860 in a frame building on East Main Street, near the present-day Catholic church. In 1888, the congregation built this church at the corner of Broad and Court Streets. A new sanctuary, constructed in 1978, can be partially seen on the right side of the photograph. Soon afterward, the old building was demolished. (Photograph by Jack Elliott.)

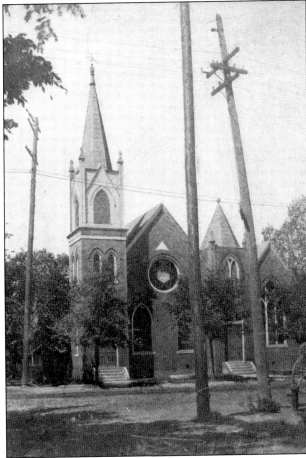

METHODIST CHURCH, C. 1910. Methodists used the building shown on this postcard, on the northeast corner of Broad and Court Streets. This church was built in 1893, following the destruction of the first building in the great fire of 1892. It was sold in 1922 to the Christian Church when a new church building was constructed across the street. The First Christian Church continues to use this structure. (Courtesy of Elizabeth Calvert.)

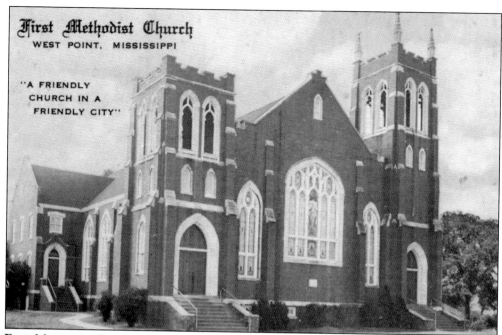

First Methodist Church

WEST POINT, MISSISSIPPI

"A FRIENDLY CHURCH IN A FRIENDLY CITY"

FIRST METHODIST CHURCH, C. 1941. The First Methodist Church purchased the lot located on the southeast corner of Broad and Court Streets in 1917. Construction, initially delayed by World War I, finally began in 1920 and continued through 1922, with the first service being held that same year. The church continues to meet in this building today. (Courtesy of Elizabeth Calvert.)

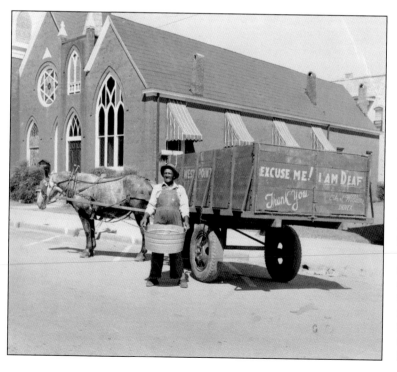

ALBERT WILLIAMS AND HIS WAGON. Williams was a common sight on the streets of West Point, with his horse and wagon, from the 1930s to 1950. He did not allow deafness to slow him down. In the background is the First Christian Church, which was originally the Methodist church.

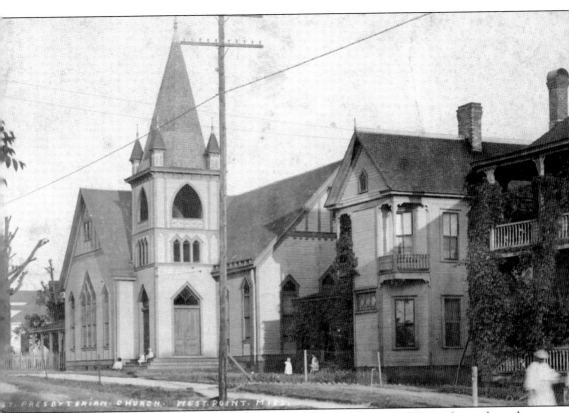

First Presbyterian Church, c. 1900. First Presbyterian Church US was located on the south side of Broad Street and west of Calhoun Street. This denomination separated from the Presbyterian Church USA in 1861 and became known as the Presbyterian Church US, also as the Southern Presbyterian Church. In 1924, the remaining Cumberland Presbyterians merged with this congregation.

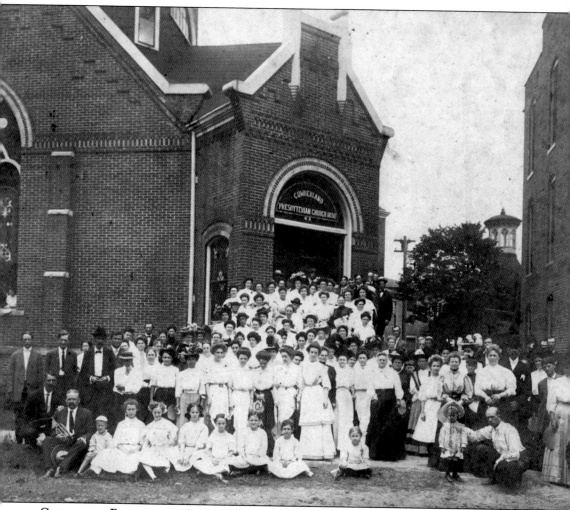

CUMBERLAND PRESBYTERIAN CHURCH, BROAD STREET. The church in this Howard Tees photograph was the second building constructed by the denomination, in 1898; the first was at 218 East Street. In 1906, the Cumberland Presbyterians merged with the Presbyterian Church USA, and the building was operated under the latter rubric from 1906 to 1953. Later used by the Church of Christ and the Pentecostal Church, it is now demolished.

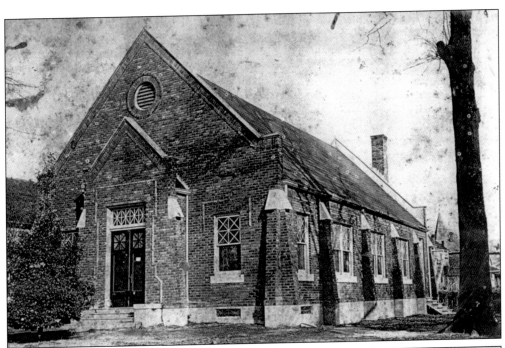

CUMBERLAND PRESBYTERIAN CHURCH, EAST STREET. The Cumberland Presbyterian Church inhabited its third building, at 314 East Street, from about 1910 to about 1924. After the 1906 merging of the Cumberlands with the Presbyterian USA, some Cumberlands did not unite. They formed a new congregation with a new building. Over the years, the congregation dwindled and eventually united with the Presbyterian Church US. The building was sold and converted into a private residence. (Courtesy of Marcia Phyfer.)

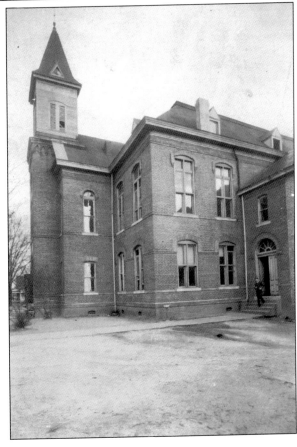

LYNCH HIGH SCHOOL. The school was named for Capt. James D. Lynch of West Point, who was named poet laureate of the 1893 Columbian Exposition in Chicago in honor of his poem "Columbia Saluting the Nations." The school, erected in 1888, burned down in 1927. It was replaced with a new high school, known today as Central School.

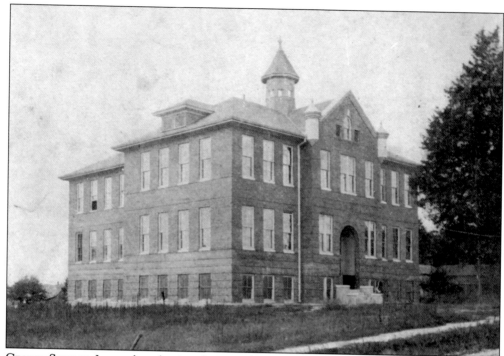

GEORGE SCHOOL. Located on the site of present-day West Side Elementary School, this school was named after US senator James Z. George (1826–1897). It was constructed soon after its lot was purchased in 1905. After being used for about four decades, it was demolished in 1947, a victim to progress. (Courtesy of Elizabeth Calvert.)

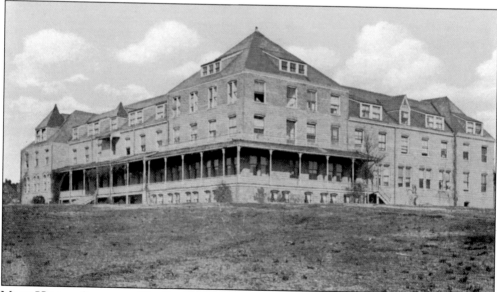

MARY HOLMES SEMINARY. The Presbyterian-run Board of Missions for Freedmen founded Mary Holmes Seminary in Jackson, Mississippi, in 1892 as a school for black women. After its first building burned down, the seminary moved to West Point, where this building was constructed in 1896 and dedicated on January 1, 1897. It burned down in 1899 and was rebuilt. It later became coeducational and was last known as Mary Holmes College. (Courtesy of Elizabeth Calvert.)

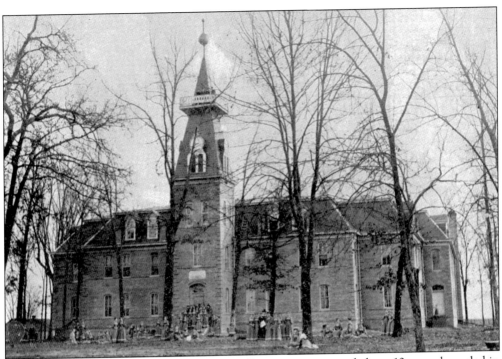

SOUTHERN FEMALE COLLEGE. The park-like college campus covered about 10 acres, bounded in part by Main Street on the north, McClellan Street on the west, and Broad Street on the south. The main building, seen in the above photograph about 1896, stood astride what is now East Jordan Avenue Extended. It was two and a half stories high, with classrooms and offices downstairs and dormitory rooms upstairs. The college was operated from 1894 to 1905 by the Cumberland Presbyterian Church, with A.N. Eshman as president. Below, students pose on a bridge on the campus about 1898. The campus area is now subdivided into residential lots. The only building remaining is the infirmary, located on East Jordan Avenue Extended.

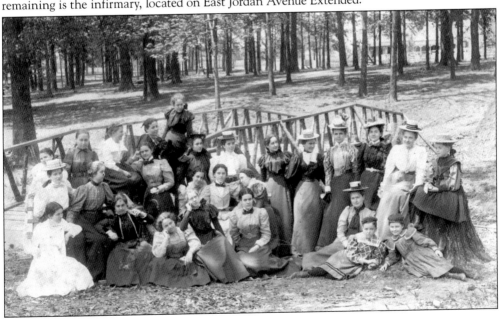

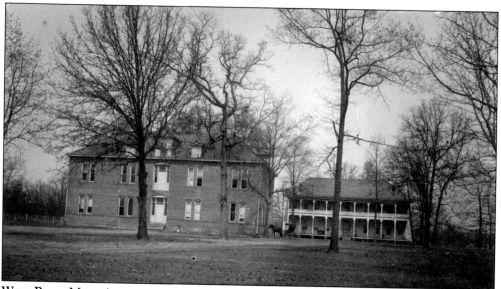

WEST POINT MALE ACADEMY, C. 1900. Founded around 1894, the school was originally known as the West Point Military Academy. It was located on the west side of Eshman Avenue and at the north end of College Street. The above photograph shows the brick academic building, with the frame dormitory to the right. The school was closed in the first decade of the 20th century. Below is a group photograph taken on the park-like grounds of the academy. The man standing second from left below, identified as "C.L.W.," is probably Charles L. Wood, a civil engineer who served as the academy's vice president in the 1890s. Wood's 1907 cadastral survey of West Point hangs on the wall of the Clay County Chancery Clerk's Office.

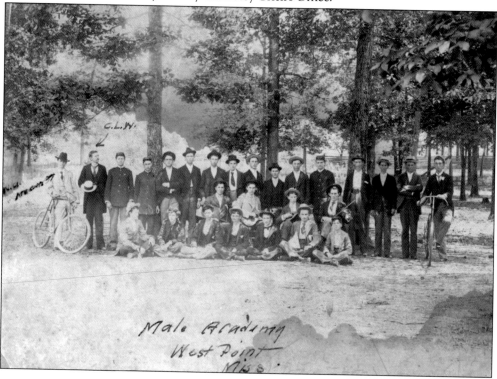

TWENTY ACRES. William Jordan was a brother of Moses and Charles Jordan, two other early settlers. His Eshman Avenue home was constructed of logs, possibly in the early 1850s. Around 1900, it served as the home of Rev. William H. Buntin, president of the West Point Male Academy, located just across Eshman Avenue from the house.

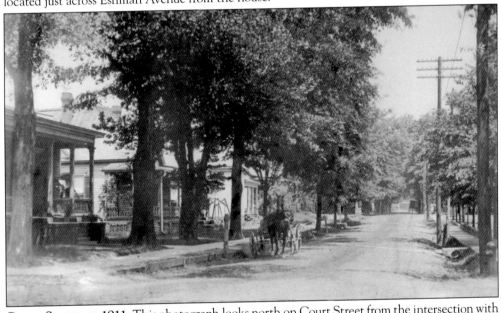

COURT STREET, C. 1911. This photograph looks north on Court Street from the intersection with Tournament Street. Although automobiles existed at this time, there are none in sight on the street; only two horse-pulled vehicles are present. Today, Court Street maintains the ambience of a residential street of the late 19th and early 20th centuries. (Courtesy of West Point–Clay County Museum.)

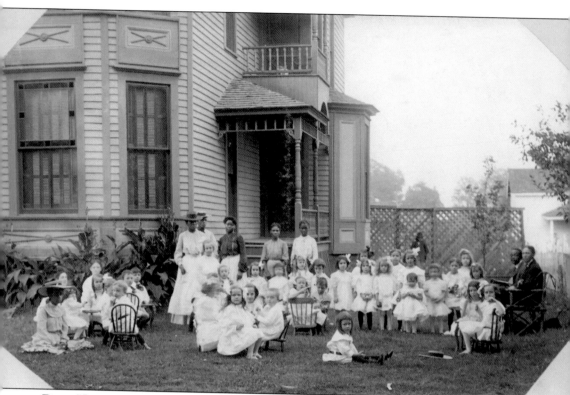

DAVIS HOUSE, 1904. A children's party is held at the Davis home on Court Street. The home was built about 1897 by John Davis, who owned the adjacent J.E. Davis Cotton Gin and Grist Mill, a large brick structure located on the site of the First United Methodist Church. The gin and mill gave its name to Mill Street, which bounded the eastern side of the Davis house and mill. (Courtesy of Elizabeth Calvert.)

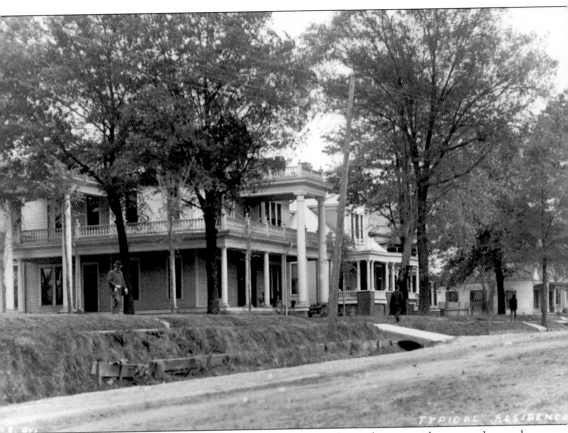

JAMES P. UNGER HOME, 1909. This photograph by Howard Tees depicts residences on the north side of East Main Street in West Point, including the James P. Unger home (left). In the 1960s, these houses were demolished and replaced by the Plaza Shopping Center, where the Sunflower Food Store is currently located. (Courtesy of Marcia Phyfer.)

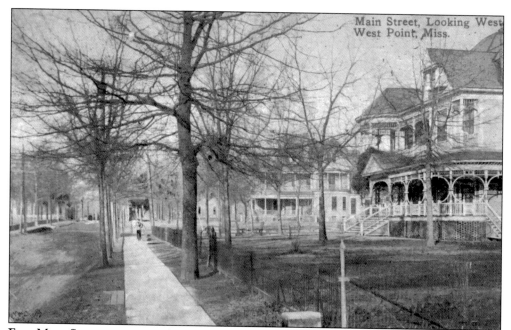

EAST MAIN STREET, C. 1910. This west-facing view of East Main Street appears on a postcard. In the early 20th century, this section of Main Street was one of the most popular residential areas in town. On the right is the Isham Evans home (later owned by Henry Foster). To its left can be seen the home of attorney Frank Critz Sr. (Courtesy of Elizabeth Calvert.)

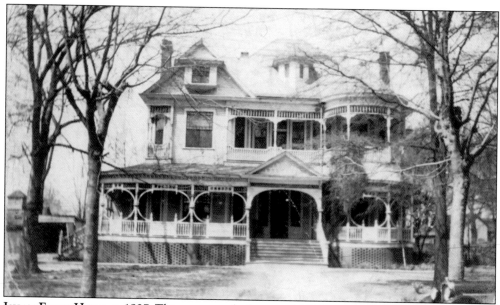

ISHAM EVANS HOME, C. 1937. This structure, built around 1900, was certainly one of West Point's most ornate Victorian homes. Located on the northeast corner of Main and Sixth Streets, it was later owned and occupied by the Henry Foster family. During the last years of its existence, most of its distinctive gingerbread decoration had been removed. The home was demolished several decades ago.

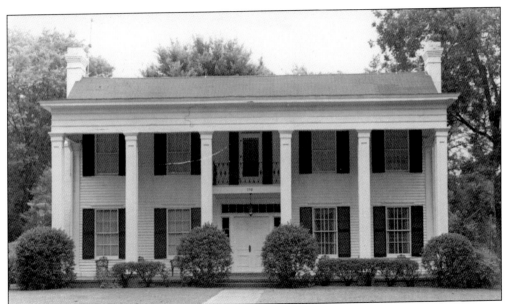

JAMES M. COLLINS HOME. Collins was a businessman in partnership with B.M. Howorth Sr. in the river town of Barton. In the late 1850s, with the coming of the Mobile & Ohio Railroad, Collins and Howorth moved to West Point, where they established the partnership of Collins, Howorth & Jordan. The third member of the firm was Moses Jordan, the founder of West Point. This home, on East Main Street, was probably built in the late 1850s.

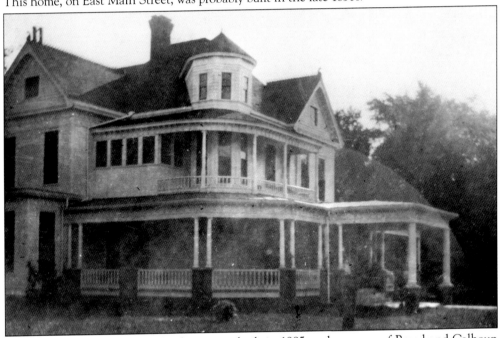

HOPKINS-COTTRELL HOME. This house was built in 1885 at the corner of Broad and Calhoun Streets for Dr. John Hopkins. It was purchased by J.W. Jamison in 1902, and then by J.A. Croom in 1906. Croom's daughter Elma inherited it in 1910, and it thereby became the home of Elma and her husband, David Cottrell, who was West Point's mayor from 1910 to 1920. The house is now owned and used by Robinson Funeral Home.

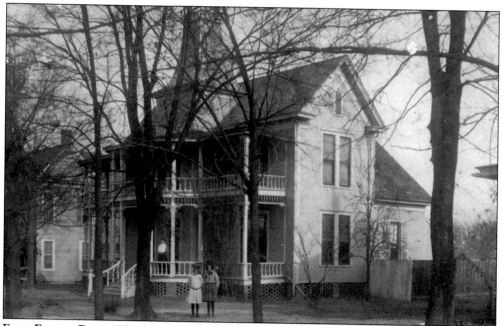

FORD-FENTON-BOGAN HOUSE, 1906. This home was located on the east side of Calhoun Street, in the second lot north of Broad Street. It was probably constructed in the late 19th century and is representative of Victorian architecture. Note the elaborate spindle work on the balustrades and the turret with a mansard roof above the entrance. The home is still extant. (Courtesy of Neill Bogan.)

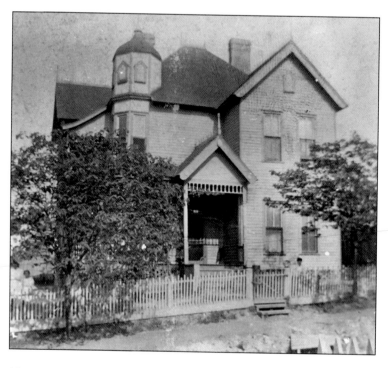

O'HARA HOUSE, c. 1910. The O'Hara house, constructed between 1898 and 1905, was located on High Street on the south side of Murff Row. It was first identified, in 1905, as the Champion House on Sanborn Insurance maps, suggesting that it was originally a boardinghouse. It was later owned and occupied by the family of Ernest Earl O'Hara, who married Allie Ray Murff. She was the daughter of S.A. Murff, founder of Murff Row.

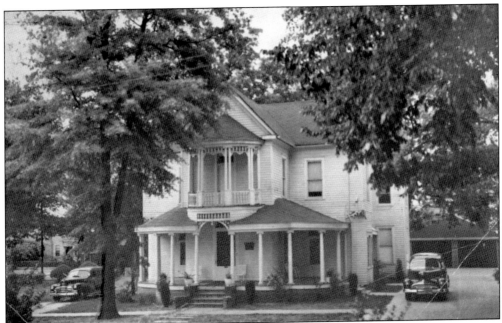

McEachin Home. The Dr. John McEachin (pronounced "McCann") home on Broad Street was constructed prior to 1885 as a one-story residence. Between 1898 and 1905, it was enlarged and became a two-story dwelling. In the early 20th century, it was owned and occupied by McEachin's daughter Margaret and her husband, Sid Deanes, a county politician. Used for decades by Calvert's Funeral Home, it was demolished in 2011.

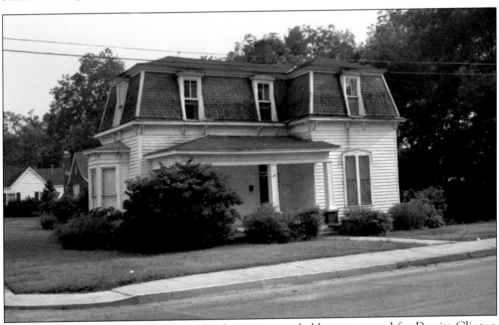

Dewitt Anderson House, 1978. This home was probably constructed for Dewitt Clinton Anderson (1854–1945) in about 1883, the year in which he and his wife acquired the lot from his family. This house is the only surviving example of Second Empire architecture in West Point, characterized by the distinctive mansard roof. (Photograph by Jack Elliott.)

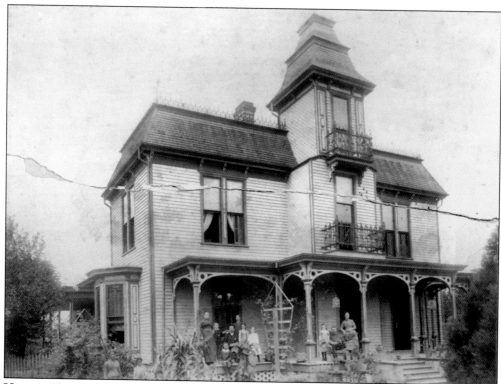

HIBBLER HOME, C. 1900. This was the residence of Talbot and Alice Stacy Hibbler in the late 19th and early 20th centuries. "Tol" was a Confederate veteran and, later, a salesman. The house was constructed around 1880 in the Second Empire style on the southwest corner of Broad and High Streets. It was demolished in the early 20th century.

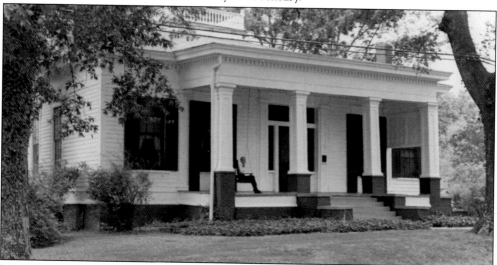

MOSES JORDAN HOME, EARLY 1970s. This Greek Revival home was constructed in the 1850s by Moses Jordan, the founder of West Point, and initially stood facing Main Street near present East Jordan Avenue Extended. In the 1890s, it was used as the home of the president of the Southern Female College, while in the early 1900s, it was moved to its current location on East Broad Street.

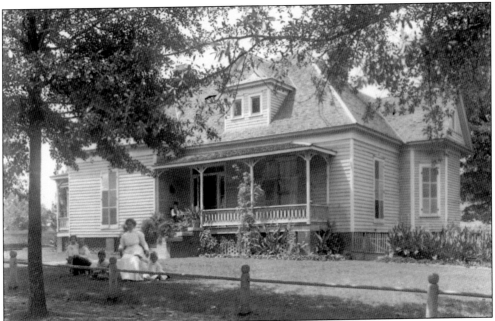

HOWORTH HOME. This residence, seen here in the first years of the 20th century, stood on the southwest corner of Grove and Travis Streets. It was the home of several generations of the Howorth family, including Joseph Russell "Joe" and Blanche Halbert Howorth. The people in the yard and on the porch are not identified. (Courtesy of Marcia Phyfer.)

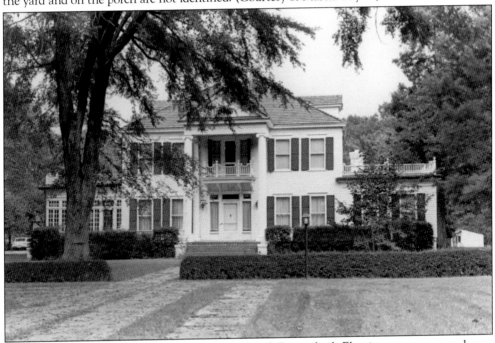

ELMVIEW. In the 1850s, George and Lucy Westbrook Brame built Elmview as a one-story house on their large estate on Brame Avenue, at the southern end of South Division Street. In 1888, the property was sold to Mr. and Mrs. Andrew F. Fox, who rebuilt the home in the Neoclassical style and added the second floor with the two large columns.

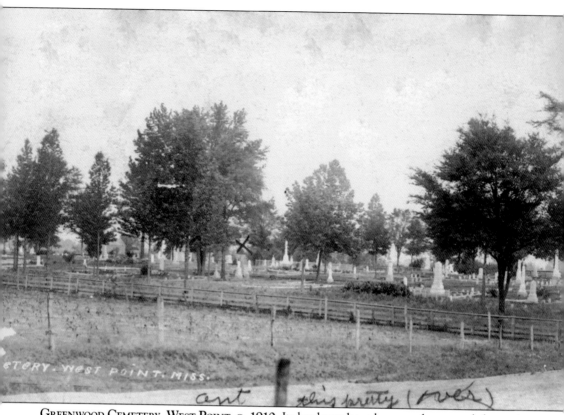

GREENWOOD CEMETERY, WEST POINT, C. 1910. Its land may have been used as an early homesite of Moses Jordan in the 1840s and early 1850s. The earliest known grave in Greenwood Cemetery is that of 12-year-old Carrol Jordan, son of Moses's brother William, who died in 1855. In 1870, the Star Lodge No. 84 Independent Order of Odd Fellows acquired the cemetery, and the lodge managed it until 1974. (Courtesy of Edwin Ellis.)

Eight

THE RURAL COUNTY

For over a century, West Point's hinterland in rural Clay County served as the economic base for the town. The farms, small and large, brought into the area the revenue needed to support the services found in West Point and in the scattered hamlets that dotted the area.

The farms were devoted in part to producing subsistence crops to feed the home folk and cotton to bring in cash. The subsistence economy gave the people a certain degree of self-reliance that transcended swings in the cotton market. Consequently, a common expression heard more than once about the Great Depression was, "we had no money, but we never went hungry!"

The farms were characterized by the homes of farmers and the clusters of surrounding outbuildings, such as barns, corncribs, cotton sheds, and smokehouses. When traveling photographers captured images of these homes, beginning usually in the early 20th century, they typically had the family stand in front of the house. As a consequence, the surrounding outbuildings were seldom recorded for posterity.

Amidst the farms were numerous hamlets that gave their names to surrounding communities, such as Palo Alto, Abbott, Tibbee, Siloam, Cedar Bluff, Pheba, Montpelier, and Una. In the 19th century, almost all locations had post offices, stores, churches, and schools. Many crossroad hamlets in the late 19th and early 20th centuries consisted of a store and a cotton gin.

As the agricultural economy declined after World War II, cotton faded as a commercial crop. Farm families abandoned the subsistence economy in favor of purchasing food from supermarkets. Areas that had been used in row cropping were often placed in pasture or tree farming.

Today, there are few rural families who gain their entire livelihood from agricultural pursuits. Most rural dwellers have jobs in West Point, at Mississippi State University, or in Columbus. Those who engage in agriculture usually do so as a part-time occupation. In effect, the rural area that once supplied the economic base for the county is now a large bedroom community for nearby urban areas that constitute the new economic base.

WASH DAVIS STORE, 1970S. In the early 20th century, George Washington "Wash" Davis, a black entrepreneur, operated a store and cotton gin on the south side of present Highway 50, east of West Point. At the time of this photograph, the store was being used as an antiques shop. Another black family, the Matthewses, also operated a cotton gin in the prairie east of town.

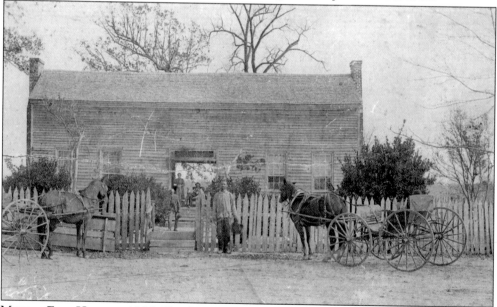

MELTON-EAST HOME, C. 1900. This house was built before the Civil War by Reuben A. Melton (1812–1861) in Melton Bottom in eastern Clay County. It was later occupied by the family of his daughter, Rebecca, who married John W. East. Note the open hallway (dogtrot), used to provide shade and ventilation, and the "paling" fence typically used to keep livestock out of the yard. (Courtesy of Suzy Pierce.)

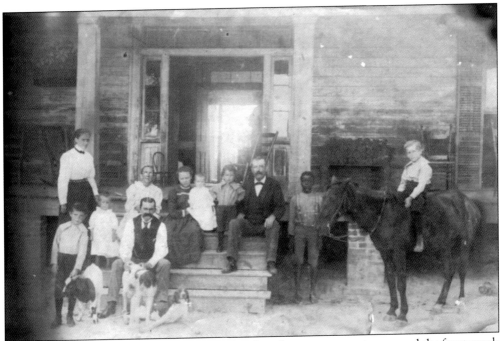

WILLIAM T. EAST HOME, C. 1900. The East family is shown congregating around the front porch of the William Thomas East house. Note the open hallway that permitted the movement of air during hot weather. No grass is visible on the ground, evidence of the practice of scraping yards to remove grass. (Courtesy of William Friday.)

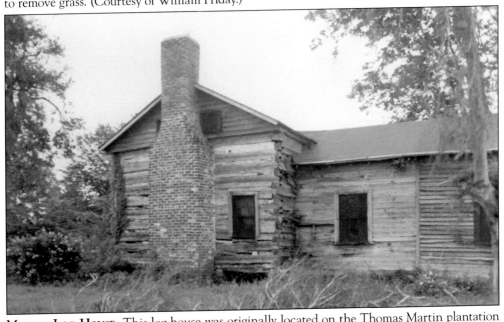

MARTIN LOG HOUSE. This log house was originally located on the Thomas Martin plantation near Waverly and was probably constructed in the late 1830s. Martin, who was an absentee landowner, resided in Pulaski, Tennessee. The house was occupied initially by his overseer, David Cottrell. It has subsequently been moved twice and is now located on the land of Toxey Haas, a descendant of Cottrell.

TIBBEE LAKE, C. 1910. There are no natural ponds or lakes in the uplands of Clay County. Consequently, fishermen had to travel to creeks, the Tombigbee River, or Tibbee Lake, an apparently abandoned channel of nearby Tibbee Creek. For decades, before the opening of larger lakes, Tibbee Lake was a favorite recreation spot in the county. This photograph is from a postcard dated March 28, 1911. (Courtesy of Reggie Pierce.)

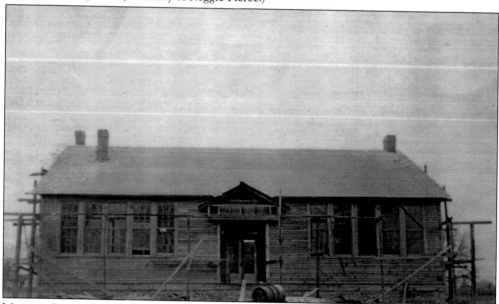

MUNGER SCHOOL AT TIBBEE. This school in the Tibbee community was built around 1925 on two acres of land for a total cost of $3,900. The school accommodated three teachers. It was partly funded by the Rosenwald Fund, a rural school-building program for African American children. Julius Rosenwald, who founded the fund in 1917, was part owner of Sears, Roebuck & Company and served as its president and chairman.

OLD TIBBEE CREEK BRIDGE. Constructed in 1896 by the Southern Bridge Company of Birmingham, Alabama, the old Tibbee Creek Bridge is located on Tibbee Road, the former main north-south road leading into West Point. Although abandoned, the bridge still stands as one of the oldest steel-truss bridges in the state of Mississippi. (Courtesy of West Point–Clay County Museum.)

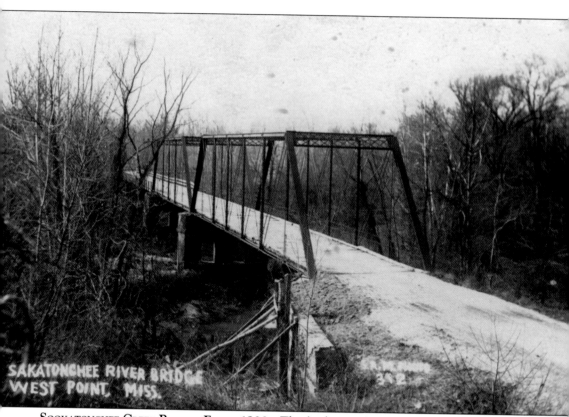

SAKATONCHEE RIVER BRIDGE
WEST POINT, MISS.

SOOKATONCHEE CREEK BRIDGE, EARLY 1900s. This bridge was located about three miles west of West Point. Constructed around 1900, it was located on the south side of the current bridge. The Battle of West Point, also known as the Battle of Ellis Bridge, was fought here on February 21, 1864. At that time, the span was known as Ellis Bridge, after Dr. Daniel Ellis, who lived nearby.

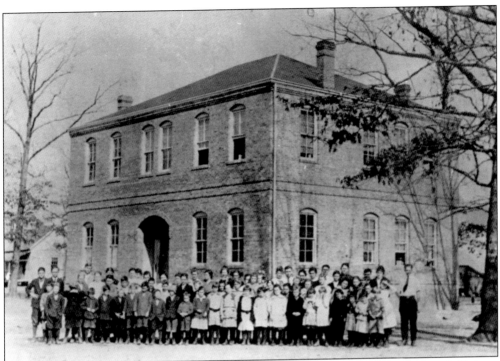

SILOAM SCHOOL, 1917. Siloam School is shown with students, teachers, and principal W.E. Shelton, probably on the right. The two-story brick school was constructed about 1914, when several area schools were merged into the Siloam Consolidated District. A frame elementary school was later added across the road to the north. When the high school was consolidated with the West Point school in 1954, the brick building was abandoned. It was demolished around 1960.

SLOAN-ROBINSON HOME, C. 1900. The Sloan-Robinson house at Siloam was constructed about 1850 by William Sloan. It was later occupied by his daughter Fannie and her husband, Henry Clay Robinson. The couple poses here with their children in front of the house. Shown are, from left to right, Clay, Henry, Bessie, Alex, Frank, Sarah, and Fannie (behind the fence). (Courtesy of Robbie Robinson.)

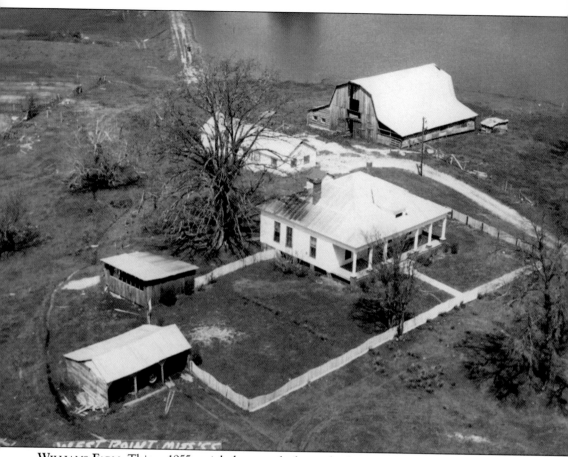

WILLIAMS FARM. This c. 1955 aerial photograph shows the farmstead of Mrs. A.C. Williams at Siloam, formerly occupied by the Powhatan Miller family. The home and most of the buildings appear to date to the early 20th century. Behind the house is a dairy barn. At upper center is a gambrel-roofed barn with a large loft for hay storage and stalls downstairs for mules and other livestock.

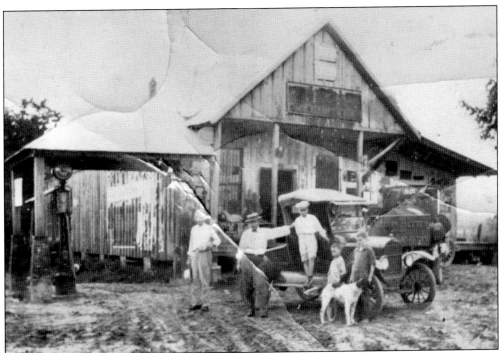

W.A. Elliott and Son Store, c. 1924. The store operated in Palo Alto from 1906 to 2012. Founded by William Abner Elliott, it was later operated successively by his son L.E. "Lid" Elliott Sr., his daughter-in-law Catherine "Kittie" Hill Elliott, and grandson Jack D. Elliott Sr. The building in the photograph was torn down in 1951 and replaced by another store building that is currently standing. (Courtesy of Jack Elliott.)

Col. F.M. Abbott Home, c. 1920. This two-story brick Italianate home was constructed by Colonel Abbott in the early 1880s and became the center of the village of Abbott. It remained a monumental landmark in western Clay County until it was demolished in the early 1960s. At the time of the photograph, it was occupied by the Judson N. Harrold family. (Courtesy of Princella W. Nowell.)

ABBOTT STORE, 1978. This store at Abbott was built in 1901 by Col. F.M. Abbott, who owned most of the buildings and real estate in the village. The first merchant to occupy the building was H.M. Ivy & Company, followed shortly after by S.G. Chandler & Company. This structure is the last commercial building standing in the village, which at one time had as many as four stores. (Photograph by Jack Elliott.)

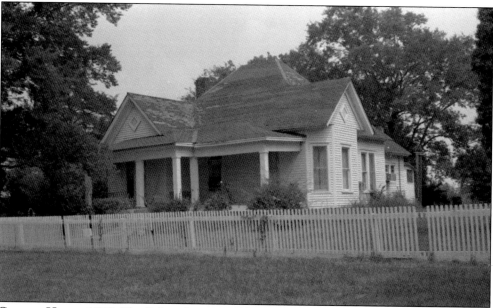

CALVERT HOUSE, 1978. The Calvert house at Abbott was constructed in the late 19th century by Colonel Abbott. During Abbott's heyday, it was occupied by various professionals, including, and possibly first, Dr. T.G. Ivy. After the Calvert family acquired the Abbott property, various family members occupied the house, with the last being Robert L. Calvert III and family. (Photograph by Jack Elliott.)

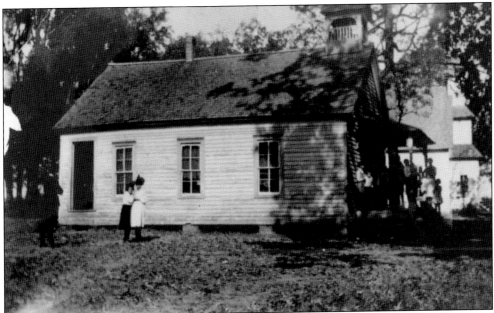

ABBOTT SCHOOL, C. 1920. This schoolhouse was built about 1910 in the village of Abbott. It faced east and was located west of the stores at Abbott and south of the Abbott Christian Church, which can be seen in the background. The school was only used for a few years before being consolidated into the Siloam school system. (Courtesy of Jack Elliott.)

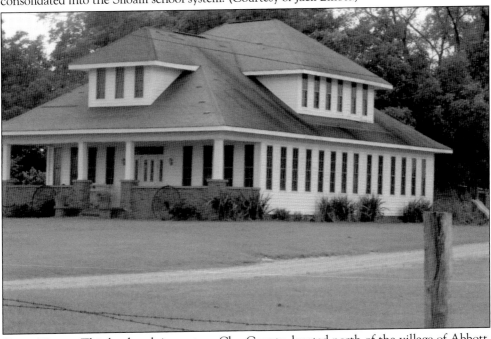

GLASS HOUSE. This landmark in western Clay County, located north of the village of Abbott, was constructed around 1917 by James Robertson Walker for his cousin Ben Walker Sr. The owner of hundreds of acres of prairie land, Ben Walker had previously lived in another landmark house, the Prairie Queen. A few years later, he sold most of his Clay County holdings and moved to the Mississippi Delta.

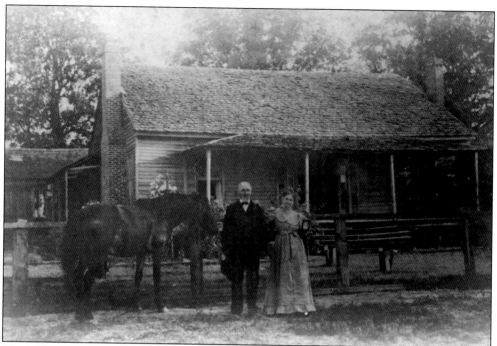

WARD HOME, C. 1900. The Ward home was located about four miles northeast of Palo Alto. Note the open dogtrot. William Andrew Ward (1843–1927) and his wife, Mary "Mollie" Bonds Ward (1846–1903), are standing in front. Mrs. Ward was the great-aunt of Lucille Miller, for whom the local history room at the Bryan Public Library was named. (Courtesy of Jack Elliott.)

CHANDLER HOME, C. 1910. A.M. "Pomp" Chandler and his second wife, Rowena Coopwood Chandler, are shown, along with household servants, in front of their home, which was located about four miles northeast of Palo Alto. A few years later, due to their age, the Chandlers moved to West Point to live with their son T.K. Chandler. (Courtesy of Jack Elliott.)

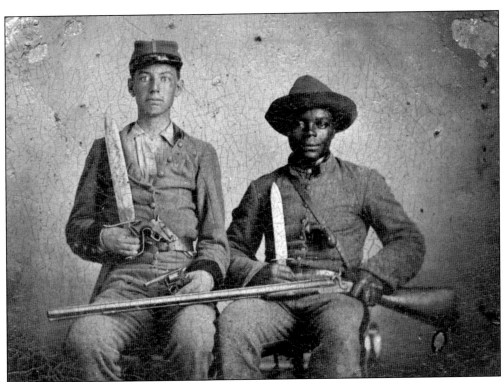

A.M. "Pomp" Chandler and Silas Chandler. A.M. "Pomp" Chandler and slave Silas Chandler of Palo Alto pose in a photographer's studio dressed in Confederate uniform and weapon props, probably in early 1861 at the beginning of the Civil War. Because of recent press and television coverage, this tintype is probably the most well-known of old Clay County photographs. (Courtesy of the Library of Congress.)

Naugle Store at Caradine. Standing on the front porch is Jefferson Boswell "J.B." Naugle Sr. (1853–1930). From 1897 to 1907, this building served as the Caradine Post Office, with Naugle as its postmaster. The village of Caradine was named after W.W. Caradine, who owned and operated a cotton gin behind the store. (Courtesy of Naugle's granddaughter, Joyce Caradine Aycock.)

J.T. Brand Store/Commissary, 1981. This store was established about 1905 as part of the plantation operation of J.T. Brand Sr. (later of J.T. Brand Jr.). It was located directly across the road from his cotton gins on Highway 47 in Brandtown. These businesses provided supplies to tenants on his place as well as to other farmers. (Photograph by Jack Elliott.)

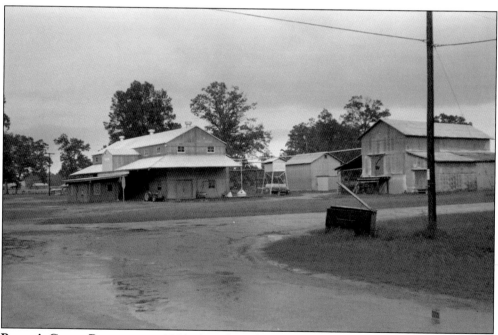

Brand's Gin at Brandtown, 1979. At right is the older gin that was run by steam power, and at left is the newer gin, run by electrical power. At the time of this photograph, the gin was no longer in operation. All of the county's gins had closed by 1970. (Photograph by Jack Elliott.)

BRAND'S GIN BOILER, 1979. An old boiler is shown here, with the old Brand's Gin at Brandtown in the background. The use of steam power for gins and mills became popular in Clay County in the mid-19th century and continued until steam power was replaced by internal combustion engines and electrical power. (Photograph by Jack Elliott.)

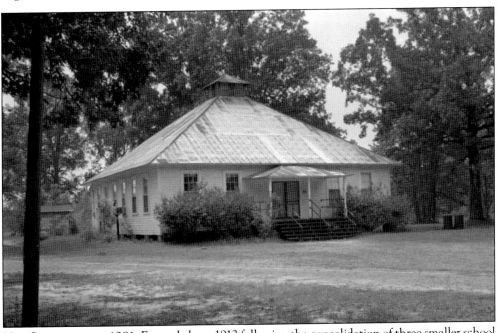

UNA SCHOOLHOUSE, 1981. Erected about 1912 following the consolidation of three smaller school districts into the Una School District, this building consisted of two classrooms, a hallway, and a large auditorium. In 1936, the school was closed, with the students going first to Prairie, then to Siloam, and eventually to West Point. The schoolhouse was used afterward as a community club. (Courtesy of Jack Elliott.)

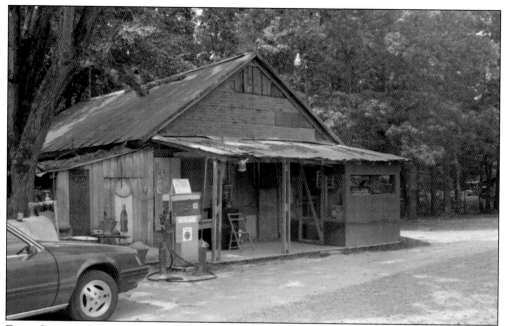

ZELLA STEELE'S STORE, 1978. This business, located off the beaten path in the Una community, was known for years for its talking parrot. The building, originally located in the Una village before it was moved to this location, was a small version of a typical gable-front store. (Photograph by Jack Elliott.)

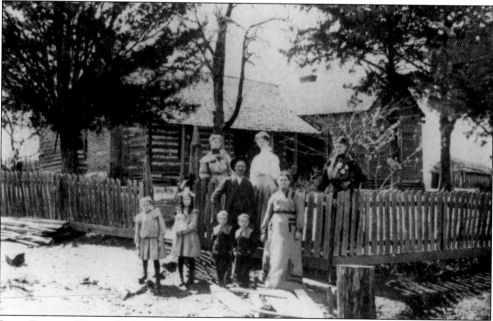

JOHN DEXTER HOME. Built in the 1840s for John Dexter (1798–1864) and his wife, Elizabeth Hamilton Word Dexter (1811–1881), this building was a log dogtrot house with a frame ell in front. The home stood on a knoll near Barr Hill. This photograph, dating to the first decade of the 20th century, depicts John's son Richard Dexter (1850–1930) and his wife, Elizabeth "Bettie" Barr Dexter (1859–1938), surrounded by their children in front of their home.

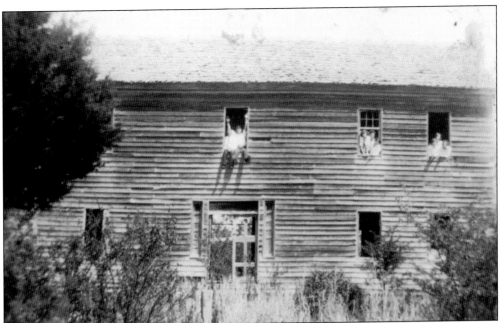

KILGORE HOUSE, C. 1927. Located in the northern part of the Kilgore Hills, this home was built, probably in the 1840s, for Dr. Benjamin Kilgore (1792–1864). It was a log I-house—that is, the main part was one room deep, had two rooms with a central hallway, and was two stories high. The Kilgore Hills were named after Dr. Kilgore, who was the postmaster at a post office named Clear Springs from 1847 to 1853. (Courtesy of Bennie Clark.)

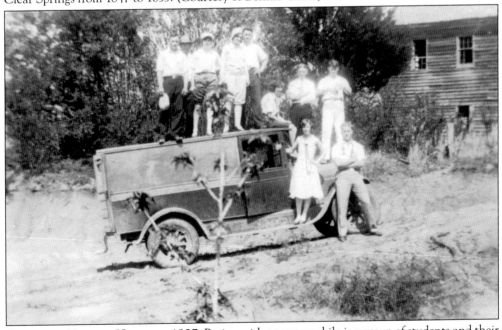

OUTING TO KILGORE HOUSE, C. 1927. Posing with an automobile is a group of students and their teacher from Montpelier. They had driven into the Kilgore Hills to visit the abandoned home. By this time, the last member of Dr. Kilgore's family was a daughter, Hattie (1842–1935), who was residing with the Nolan family. (Courtesy of Bennie Clark.)

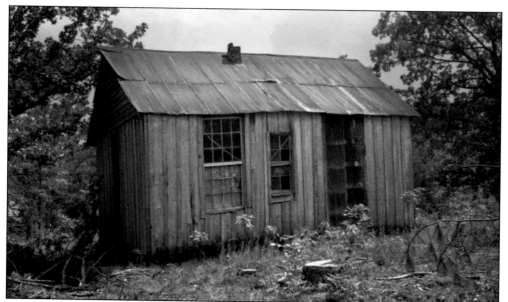

RASBERRY SCHOOLHOUSE, 1978. This school, established for black children who lived in the Kilgore Hills area, was named after the Rasberry family. Having stood vacant for decades when this photograph was taken, the abandoned schoolhouse continued to deteriorate until it effectively "rotted down." (Photograph by Jack Elliott.)

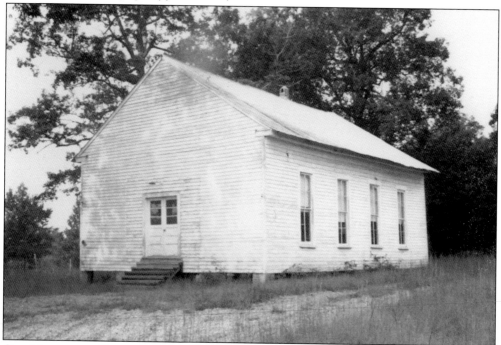

OLD MONTPELIER BAPTIST CHURCH. This church was located south of the Old Montpelier Crossroads, which gained its name from its close proximity to the original site of the Montpelier Post Office, established in 1853. The church was founded in 1885, after the post office had moved away, and this building was erected in the early 20th century. Like most rural Southern churches of the time, this one did not have a steeple.

MONTPELIER POST OFFICE, 1980s. The post office was established in 1853 about three miles east of present-day Montpelier, at the site now known as the Old Montpelier Crossroads. Over the years, the post office migrated westward until it arrived at the village of LaCross in 1891, at which time LaCross became known as Montpelier. The post office building shown here had originally served as a store. (Courtesy of Mary Louise King.)

SCOTT HOUSE, 1980. In the 1880s and early 1890s, this house, located between Montpelier and Palestine, was the home of Nancy E. Scott. She served twice as Montpelier postmistress. Initially, the post office was in or near her home. In 1891, during her second tenure as postmistress (1886–1897), she moved to the village of LaCross, thereby moving the post office and changing the name of LaCross to Montpelier. (Photograph by Jack Elliott.)

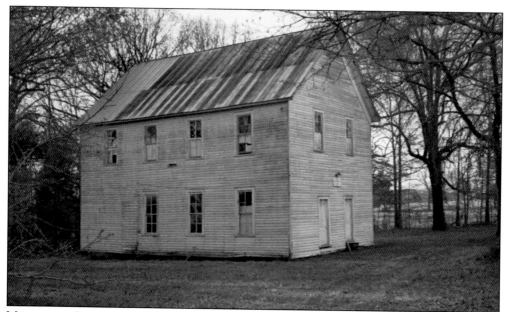

MONTPELIER CUMBERLAND PRESBYTERIAN CHURCH AND MASONIC LODGE, C. 1980. This building was constructed soon after the lot was purchased in 1895 by the church and the lodge. The Masons met upstairs. In 1958, the congregation merged with the Cairo Cumberland Presbyterian Church, and its interest in the building was sold to the Masons, who eventually built a new lodge and demolished this building. (Photograph by Jack Elliott.)

C.C. CROSS STORE, 1978. The village now known as Montpelier originated about 1882, when two stores were built there by Cross and by J.E.W. Herrington. The town was initially called JoCross, after the two merchants, but was subsequently named Cross-Katz and then LaCross. In 1891, the Montpelier Post Office was moved to LaCross, and the village's name was changed to Montpelier. The Cross store was demolished a few years ago. (Photograph by Jack Elliott.)

114

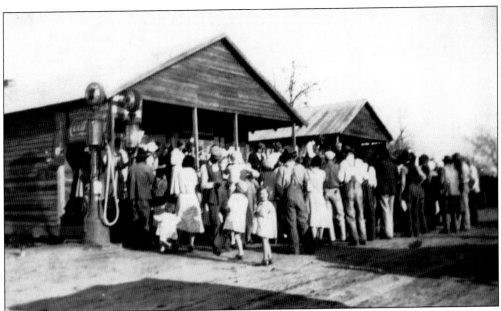

HUGHES STORE, 1920S. A crowd is gathered, perhaps to hear a politician speak, at Andrew Frank Hughes's store (left) at Cairo. To the right is what appears to be another store. Note the gasoline pumps on the left side of the store and the Coca-Cola sign behind them. The store was located on the north side of present-day Highway 46 at Cairo. (Courtesy of Bennie Clark.)

GOSA HOME, EARLY 1970S. The home of William Mortimer Gosa (1808–1890) was formerly located on Highway 46 near Cairo. The home was built in 1854, as indicated by a date inscribed on the chimney. Built of frame construction, the residence was unusual for that period, in that it had no dogtrot or central hallway. The house was demolished several years ago.

WATKINS HOME, 1978. This home in the Griffith community was built in the 1840s by John Watkins (1780–1865), the progenitor of the Watkins family in Clay County. It was last occupied by two of his descendants, Helen and Lyde Stephens. A short distance in front of the house is the Watkins Cemetery, where John and many members of his family are buried. The central portion of the structure is a log dogtrot house. (Photograph by Jack Elliott.)

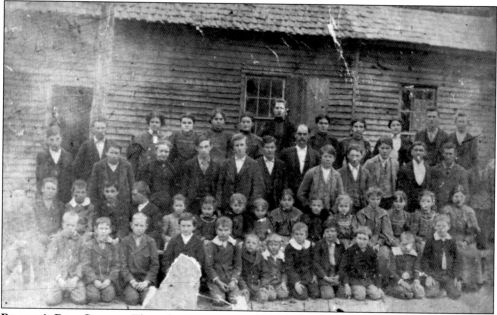

PILGRIM'S REST SCHOOL. This school, constructed on land donated by James Louis Stephens in November 1880, was located about a mile east of what later became the center of the Griffith community. About 30 feet by 50 feet in size, it was typical of many one- and two-room schoolhouses that dotted the countryside. The building burned down in 1899, and the school was afterward consolidated with the Griffith School.

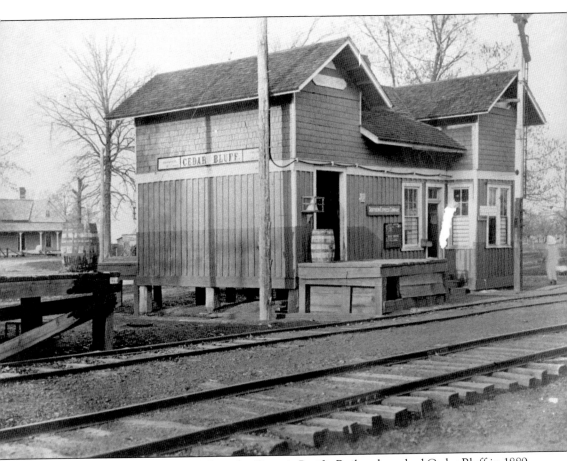

CEDAR BLUFF DEPOT, C. 1915. When the Georgia Pacific Railroad reached Cedar Bluff in 1889, the site was surveyed into a town and incorporated. By the time this photograph was taken, the railroad had become part of the Southern Railway system, which later became the Columbus & Greenville Railway. This photograph depicts the front of the depot, which faces the railroad.

CEDAR BLUFF POST OFFICE, 1970S. The post office at Cedar Bluff was established in 1847, decades before the arrival of the Georgia Pacific (later Columbus & Greenville) Railroad in 1889, which prompted the establishment of the town of Cedar Bluff. The building in this photograph stood near the old business district and depot. It was replaced about 1980 with a new post office building, located on Highway 50. (Courtesy of Eleanor Craig.)

TRIBBLE HOME. The home of Willie P. Tribble (1858–1924) was located near Cedar Bluff. The house, with its open central hallway, is of the dogtrot type that was once so common in the area. The family poses for the photographer. Note the fence that surrounds the yard, a once-common means of preventing wandering animals such as cows and hogs from devastating the yard and porch. (Courtesy of Kay Manzolillo.)

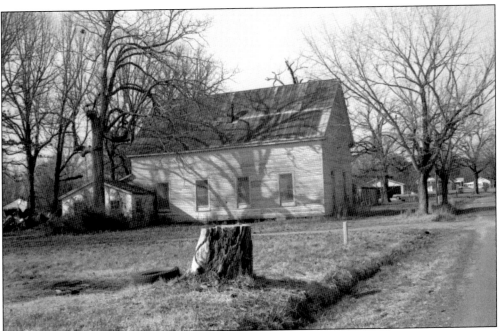

CEDAR BLUFF CUMBERLAND PRESBYTERIAN CHURCH, 1979. This church was founded prior to 1846 as the Pleasant Hill Cumberland Presbyterian Church and was located a short distance north of Cedar Bluff, at the site of the current Presbyterian Cemetery. After the railroad arrived and Cedar Bluff developed into a small town, the church was reopened in town. It closed in the 1960s due to a decline in membership. (Photograph by Jack Elliott.)

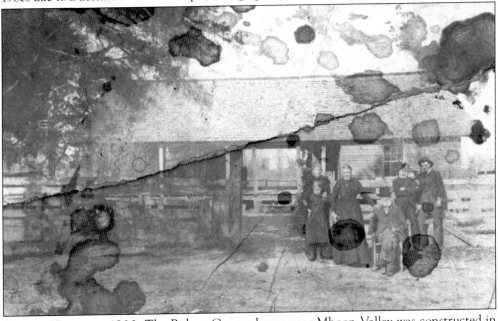

COOPER HOUSE, C. 1900. The Robert Cooper home near Mhoon Valley was constructed in the early 1860s. Clapboards covered the logs in this one-and-a-half-story, open dogtrot house. Several years ago, the deteriorating logs were disassembled and sold to French Camp Academy for restoration.

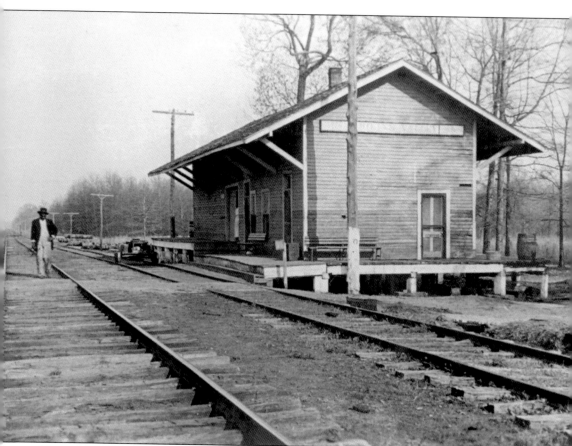

MHOON VALLEY DEPOT, C. 1915. Mhoon Valley was located along the route of the railroad originally known as the Georgia Pacific (later the Southern, and even later the Columbus & Greenville), west of West Point and south of Siloam. Note the poles for the telegraph line that followed the railroad. A town plat was surveyed at Mhoon Valley, and a post office was established there. (Courtesy of Jack Elliott.)

PHEBA POST OFFICE, 1978. The Pheba Post Office and McCarter's Grocery were located in the heart of the Pheba central business district. The post office building was originally the Pheba Bank. At the time of this photograph, there were still several frame store buildings standing, although most were abandoned. (Photograph by Jack Elliott.)

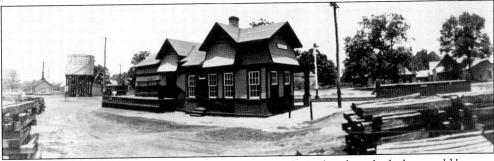

PHEBA DEPOT, C. 1929. By about 1889, the Georgia Pacific Railroad reached what would become Pheba. A depot and post office were soon established, and the town was surveyed and incorporated. A bank was established there, along with the Clay County Agricultural High School. In the right background are what appear to be several store buildings.

PHEBA CENTRAL BUSINESS DISTRICT, 1979. Seen here are, from left to right, McCarter's Grocery (originally W.T. Terry), the post office (the former bank, behind the flag), Wyatt's Grocery, Wade's Grocery, and a white store building. Of these buildings, only one, the former bank, still

stands today. It is used as a bar and is called, appropriately enough, The Bank. (Photograph by Jack Elliott.)

PHEBA METHODIST CHURCH, C. 1980. The congregation traces its origins to the Methodist church that was located in the Tampico-Henryville area, that is, the vicinity of Hebron. In 1895, the church's members purchased a lot in Pheba, demolished their old church building, and constructed the one depicted here using the lumber from the demolished building. (Photograph by Jack Elliott.)

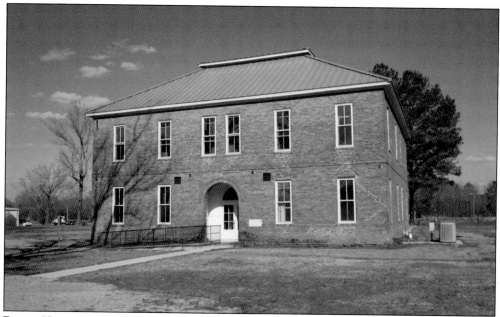

PHEBA HIGH SCHOOL, 2015. This building was constructed in 1909 to serve as the area high school. From 1912 to 1932, it was the West Clay County Agricultural School, which students from throughout the county were required to attend. In addition to this building, the campus included dormitories for girls and boys and laboratory buildings for agriculture and home economics. Restoration of the building was completed in 2012. (Photograph by Jack Elliott.)

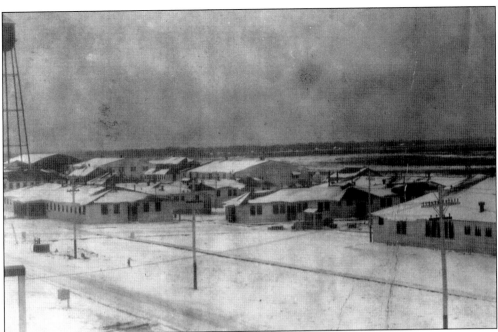

PAYNE FIELD, NOVEMBER 1918. For two years, a field three miles north of West Point served as a pilot-training facility for the US Army Air Service. The site, selected in late 1917 and opened in early 1918, was named Payne Field, after Capt. Dewitt Payne, who was killed in a crash on February 1, 1918, in Texas. Payne Field, seen here after a snowfall, closed in March 1920.

TRAINING FOR BATTLE. A squadron of Curtiss JN-4 Jennys practices flying in formation in the skies over Clay County (or at least nearby). The Jenny was the primary trainer aircraft at Payne Field, which housed as many as 300 cadets at one time. The training facility produced over 1,500 pilots before it was closed.

LT. HARRY WEDDINGTON AT PAYNE FIELD. Weddington, seen here in a Curtiss JN-4 Jenny, was one of the most experienced pilots of his day. He was the director of flight instruction at Payne Field. In 1918, he left Payne Field on a trip that covered over 2,000 miles, visiting 12 airfields along the way. According to Payne Field historian David Trojan, the trip was at the time "the longest airplane flight on record."

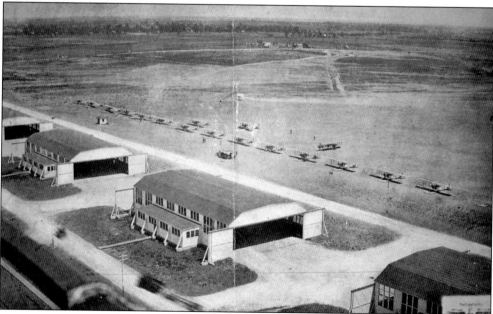

PAYNE FIELD, C. 1918. In this southeast-facing photograph, taken from the water tower, the large buildings in the foreground are hangars, of which there were 12 in all. In the background can be seen 17 of the airplanes used in flight instruction and, beyond those, the airfield. Running from left to right in the distant background is Old Aberdeen Road, with a farmstead on its far side.

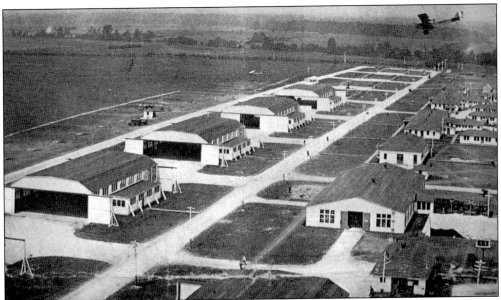

PAYNE FIELD AND HANGARS, C. 1918. The large buildings on the left are hangars. On the right of the broad drive is a row of buildings consisting of, from front to back, a machine shop, the post exchange, and two barracks. Running from left to right in the background is the right-of-way of the Mobile & Ohio Railroad. This southwest-facing photograph was taken from the water tower.

PAYNE FIELD BUILDINGS, C. 1918. To the left are the airfield and hangars. In the center are four mess halls, with barracks on either side. In the background is the Mobile & Ohio Railroad. Its spur line, which served Payne Field, runs along the right side of this west-facing photograph. There appears to be a gondola car sitting on the spur line.

DISCOVER THOUSANDS OF LOCAL HISTORY BOOKS FEATURING MILLIONS OF VINTAGE IMAGES

Arcadia Publishing, the leading local history publisher in the United States, is committed to making history accessible and meaningful through publishing books that celebrate and preserve the heritage of America's people and places.

Find more books like this at
www.arcadiapublishing.com

Search for your hometown history, your old stomping grounds, and even your favorite sports team.